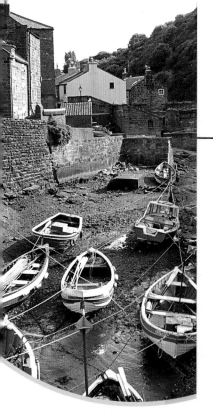

DER

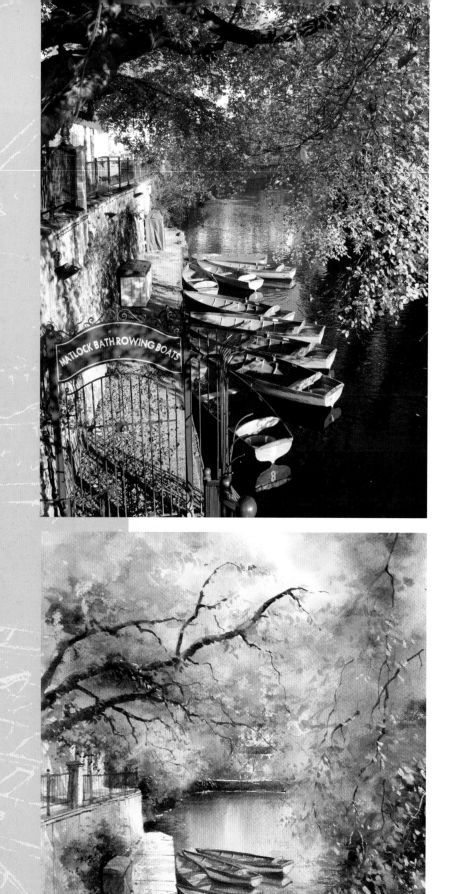

PAINTING SUCCESSFUL WATERCOLOURS

FROM PHOTOGRAPHS
Geoff Kersey

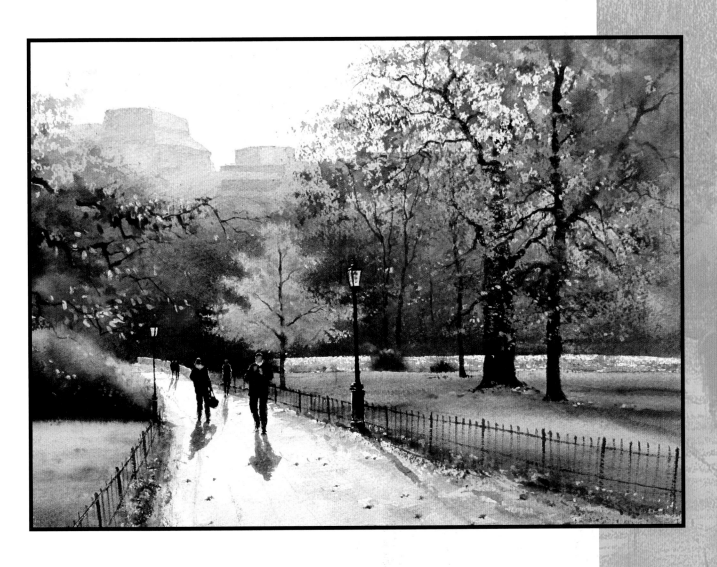

Search Press

First published 2015

Search Press Limited
Wellwood, North Farm Road,
Tunbridge Wells, Kent TN2 3DR

Text copyright © Geoff Kersey 2015

Photographs by Geoff Kersey
Photographs and design copyright
© Search Press Ltd 2015

ISBN: 978-1-84448-998-5

Suppliers
If you have any difficulty obtaining any
of the materials and equipment
mentioned in this book, please visit the
Search Press website:
www.searchpress.com

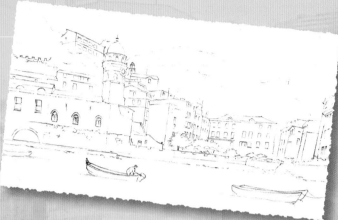

Dedication

Dedicated to my editor, Sophie, who has worked
tirelessly to turn the masses of images and
information into a coherent book.

Front cover
Hillside Village
This photograph and painting are analysed in depth on pages 24–27.

Page 1
Fishing Port
This photograph and painting are analysed in depth on pages 80–85.

Page 2
Rowing Boats
This photograph and painting are analysed in depth on pages 50–53.

Page 3
London Park
This photograph and painting are analysed in depth on pages 30–33.

Printed in China

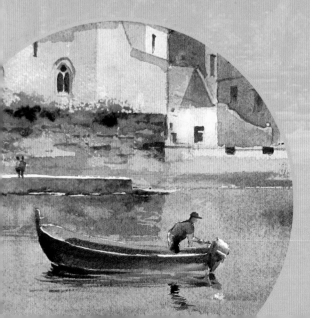

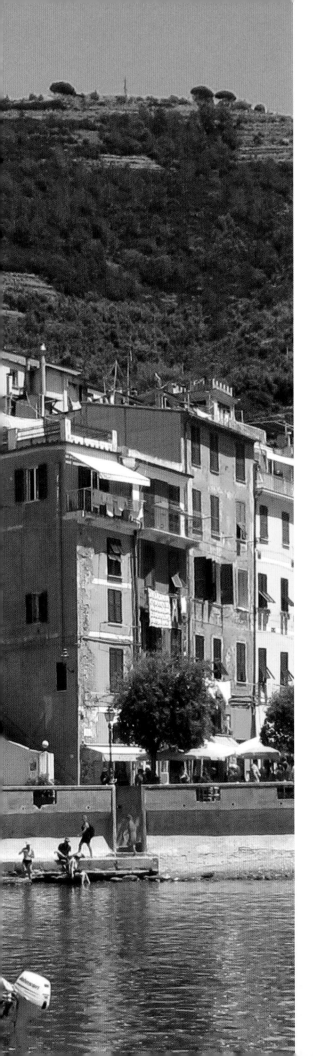

Contents

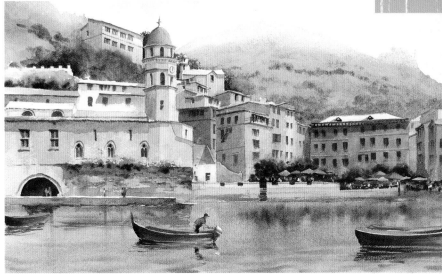

Introduction

I got the idea for this book from all the watercolour landscape painting workshops and courses that I have taught over the years. These usually take the form of me deciding on a subject, finding an appropriate photograph, printing out a copy for everyone and then demonstrating the painting process, with all the students following, step by step. I realise this method of teaching does not suit every art teacher or student, but it works for me, and those attending usually go home pleased with the results.

*View from
a hotel room,
North Laggan, Scotland*

Many people want to work from their own photographs, and indeed enjoy looking for potential subjects when they are out and about, but they often fall at the first hurdle: that of seeing the painting within the scene and knowing what to leave in and what to leave out; in other words, interpreting their photograph and translating it into a painting.

When I had just started watercolour landscape painting, about twenty-five years ago, I bought a book by an excellent watercolourist, James Fletcher Watson, who lived in the Cotswolds, UK. I was fascinated by one of his paintings, 'Windrush Mill', and while on holiday in that area, I determined to find this location and take some photographs, in order to produce my own painting of this subject. When I finally found Windrush Mill, I was disappointed. Not only did it not seem to have the magic of the painting, but try as I might, I couldn't see how the artist got the view in the painting reproduced in the book, as there was a large tree in the way. I realised at this point that you do not have to wait until you have found the perfect subject and composition; you can take what is in front of you and make it into a painting. The fact that an artist I admired had done this, made it acceptable to me. For me, this was an important realisation and lesson learned.

In my experience, you are lucky if you can find the perfect composition with every element in place, so being able to assess a photograph, see the painting within it, and interpret it, rather than copying it slavishly, broadens the number of subjects available to you enormously. In this book, I show you how I have worked mainly from my own photographs, giving insights into the choices I have made, the sketches and occasionally diagrams I have used in the process, and the colour mixes I have used in the eventual painting. This is not a book on painting techniques, but since some methods are mentioned in the descriptions I have given of the adaptation process, there is a chapter on painting techniques to help explain these at the beginning (see page 10).

This book is not about photography, and indeed the quality of the photographs is at best inconsistent. In a way though, that does not matter, as I do not want readers to think that they need a course in photography and expensive equipment in order to produce the standard of photographs needed as a starting point for a painting.

Most of the photographs featured in this book are snapshots, many taken with an inexpensive compact camera. I do have a more expensive SLR camera, but sometimes find it bulky, preferring to travel more lightly. None of the photographs are taken from inaccessible places that you need a high level of fitness to reach, or from exotic locations. In fact the photograph opposite was taken from the bedroom window of a hotel.

I hope this book will inspire you to go outdoors and look for painting subjects; to start composing the painting the moment you point the camera, and then to work effectively with the results.

Materials

Paper

Both in terms of ease of use and how it affects the finished result, I think paper is the most significant item on your materials shopping list, and buying the right one pays dividends.

As with all materials, personal preference plays a part, but my recommendation is to avoid the cheaper, wood-pulp papers; instead, look for the description 'cotton' or 'rag' when choosing papers. These are generally a little more expensive but are much tougher and more forgiving. I use masking fluid in most of my paintings and because the wood-pulp papers are weaker, there is always the possibility that the surface will tear when you come to remove it. I have seen this happen time and time again on the various painting holidays and workshops I run.

I mainly use paper with a Rough surface, occasionally selecting Not (also known as cold pressed, which has a bit of tooth or texture, but not as much as Rough) if I am painting a subject with a lot of fine detail. Dry brush techniques are much easier and more effective on Rough paper.

I use two brands, Arches 300gsm (140lb) and 640gsm (300lb) Rough and Saunders Waterford Rough in the same weights. Both these papers are made with 100% cotton, which provides a stronger surface than wood-pulp paper, but the main advantage is that it is much easier to lay a fresh wash over an earlier dried wash without disturbing the previously applied colour.

Brushes

Like all materials, the choice of brushes divides opinion, and ultimately you need to find what you prefer, and what best suits your style of painting. I personally think you do not need to spend a great deal to get a good quality brush. I prefer synthetic brushes, as I like the springy quality which ensures that as soon as you lift the brush off the paper, it returns to its shape. Synthetic brushes do not absorb as much water or paint as natural hair like sable or goat, and the advantage of this, especially when you are learning, is that less water or paint on the brush can make it easier to control, helping to avoid flooding or creating 'cauliflowers'. The one exception among my collection of brushes is the extra large oval wash brush that I use for skies. This is part squirrel, part nylon, which gives an extra absorbency, useful for covering a large area quickly.

I have flat brushes no. 2, 4, 6, 8 and 10.

I also use no. 2, 4, 6, 8, 10 and 16 round brushes, a liner/writer, an extra large oval wash brush and a rake brush.

Paints

I have a field set of watercolour pans (left) that is very compact, making it ideal for outdoor sketching and quick studies, which I can use as sources of information for later studio work. However, apart from this, I do all my paintings with tube colour, as I prefer the rapid way you can mix plenty of fluid wash. Tube paints enable you to vary the consistency quickly and easily, because the paint comes out of the tube already half-way to liquid.

There are numerous brands of paint, and again people have various loyalties and preferences, based on what they are familiar with, and what suits their work. The main difference is whether the paint is artist's quality or student's quality. Artist's quality watercolour is approximately three times the price of the student's quality; depending on the colour, the difference can be even greater. I always use artist's quality paint and believe it is worth the extra expense. I trust the artist's colour more and find the student's quality can be a false economy, because it has a greater ratio of gum to pigment, so does not go as far.

Other materials

I use the collapsible or 'lantern' type of water pot, because I carry a lot of equipment around and they are light and compact. Any type of old jar will suffice, but choose a large one, or you will be changing the water every few minutes.

Kitchen paper is a really useful material, not only for keeping everything clean, but also for creating textured effects.

Masking tape can be useful in situations when you want to mask a totally straight, neat line like the sides of tall buildings or the horizon line on a seascape. You need to experiment with different brands, as some are too sticky and damage the paper, whereas others are not sticky enough and let the paint seep underneath. Masking tape cannot be used to stretch paper as it will not adhere to a wet surface; for this purpose gummed tape is the best product.

I find mechanical pencils very useful, as they avoid the need for constant sharpening. I use three different gauges, a 5mm (3/16in), a 7mm (1/4in) and a 9mm (3/8in) depending on what I am drawing. This type of pencil usually comes with HB leads, which I find a bit hard, so I buy 2B leads to replace them.

I only use a hairdryer when I am in a hurry, for instance in a demonstration situation. However, it can be useful if you are painting wet into wet and you consider the paint has spread just far enough and want to dry it immediately to prevent it spreading further.

I use masking fluid to varying degrees on nearly every painting. There are a lot of different brands on the market. Colourless masking fluid can be more difficult to use because it is not easy to see where you have put it, so you might prefer the blue-tinted type. Keep the cap on firmly, as masking fluid deteriorates quickly if air gets to it. Ordinary soap is used to protect your brushes.

Painting techniques

Fading colour

The idea here is to fade the distant hills, keeping the clearly defined shape but softening its appearance and at the same time slightly reducing the strength of the colour. The sky and hills must be completely dry before you start. Lightly brush over the top of the hill with clean water before dabbing with a clean tissue (see below). This one attempt may well be enough, but if you wish to fade it further, repeat the exercise. If you brush too vigorously, you are in danger of removing some of the sky as well, which would be very difficult to paint back in.

This effect is much easier to achieve on a good quality cotton-based paper, as it is harder to remove colour once it has dried. Generally on cheaper, wood pulp-based papers, where the colour sits on top, it is all too easy to remove too much, wiping out the hill and sky in one go.

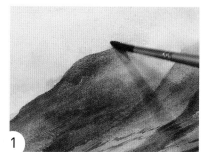

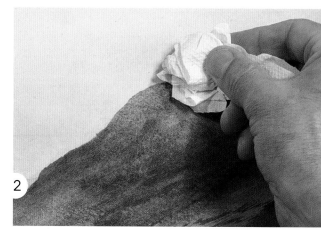

Mist and low cloud on hills

Trying to achieve what artists call the 'lost and found' effect of the mist-shrouded hills and shoreline can be tricky, but it is also quite exciting if you get it right. You need to paint the sky first and ensure it is completely dry, before commencing this stage. The key to this method is to keep brushing in clean water as you paint the hills, giving the impression that you are glimpsing the hills through the moving veil of mist and low cloud. In other words, you don't so much paint the mist and cloud as use the clear water to reveal the cloudy sky that is already there on your paper from the previous stage. Practise on a smaller scale first, perhaps with a few thumbnails before applying it to your painting. In the example shown here, you can see that I used the same mixtures of grey and blue that I had used in the sky to render the hills, so that they became part of the background.

Do try not to overwork this effect, or you will lose the feeling of light, and dabbing into drying paint can cause 'cauliflowers' or runbacks.

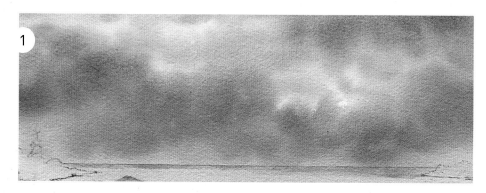

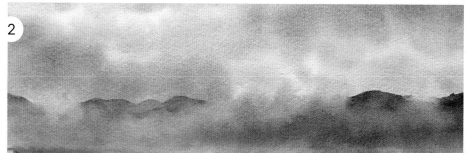

Applying masking fluid to a wet background

This is an effect I often use when I want to create a soft shape with the masking fluid rather than a hard-edged shape. It is particularly useful when you wish to mask out an area like a bush or tree or even an area of weeds, wild flowers or grasses.

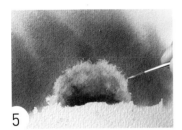

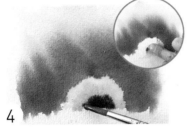

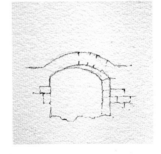

1 Wet the paper, then float in the masking fluid to create a soft-edged shape for a bush. Allow it to dry.

2 Wet the background again and float in cobalt blue for the sky, then aureolin and cobalt blue around the masked bush.

3 Drop in a mix of ultramarine, aureolin and burnt sienna to create a dark contrast with the bush. Allow to dry.

4 Rub off the masking fluid. Drop in lemon yellow, then aureolin and cobalt blue, then aureolin, ultramarine and burnt sienna.

5 Pick out a few leaf shapes using neat lemon yellow and a fine brush.

The finished bush.

A view through an opening

In a situation like this it is important that the view through the opening appears to be part of the background. In order to achieve this, it is important to paint what you see through the opening at the same time as you paint the background; but how do you avoid getting paint on the stonework?

You can see in this example, taken from the Ruined Mill painting (page 46), that once I had drawn the stone arch and surround, I masked out the shape with masking fluid; taking care to apply it generously so that no stray green paint landed on the stonework. After the masking fluid had dried, I painted into the wet background, and once the background had dried, I removed the masking fluid, leaving a crisp, white image in the shape of the stonework.

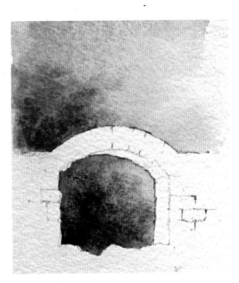

Textured, blotchy bark

This method can also be used for silver birch trees and various other textured surfaces. It can be a bit hit and miss, so practice should pay dividends. It was used for the plane tree in the Mediterranean Street Café painting on pages 76–79.

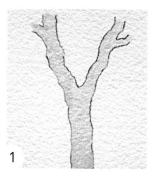

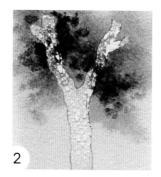

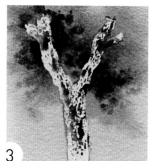

1 Draw the tree trunk in pencil, and then mask it completely with masking fluid.

2 Paint in the background with a thin wash of raw sienna, followed by a light and dark green to represent the foliage. Once this has dried, rub the masking fluid with the tip of your finger, taking care to only partially remove it.

3 Paint some raw sienna and dark brown on to the now partially masked tree trunk, giving the blotchy, uneven effect. This can then be repeated by removing a bit more masking fluid and brushing in a bit more colour.

4 When you have finally removed all the remaining masking fluid, add a touch more raw sienna to take the whiteness off.

Using flat brushes

A simple way to do windows, especially when there are a lot of them, is to use a small flat brush, sometimes referred to as 'one-stroke' brush. I have in my collection several of these brushes: no. 2, 4, 6, and 10, to give me a variety of widths to choose from, depending on the size of the painting and building. This not only speeds up the process, it also helps to make all the windows consistent in shape and size. It also makes it easier to avoid the rounded corners you can sometimes get with a round brush.

You can see from the picture that before painting the shapes, I put in a pencil grid to keep the windows roughly in line. Even in an old, weathered building, the windows line up, but this is particularly important in formal buildings like Chatsworth House, shown on page 67, or apartment blocks as in the painting of Vernazza on page 55. It is important to put in these pencil guidelines after you have painted the background colours, as it is then easy to rub them out after the window shapes have been painted. It is always worth remembering that once you paint over pencil lines, even with a thin wash, you seal them in and can't erase them.

These small flat brushes are also useful for suggesting brickwork and stonework detail.

Composing from photographs

It is always a good idea when composing your painting to remember the rule of thirds. This means that if you divide your paper into three equal sections across and three down, the four points at which these lines cross are excellent places to position your focal point (see Diagram 1). Note how in the example below, a compositional sketch, the house, which is the focal point, is positioned at point D. I moved the house there from the position it occupied in the photograph to improve the composition.

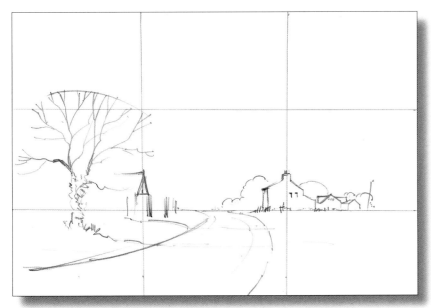

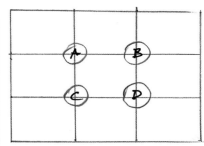

Diagram 1

Another aspect of the rule of thirds is the simple L-shaped composition, shown in Diagram 2, below right. Note how I have used this in the compositional sketch shown below.

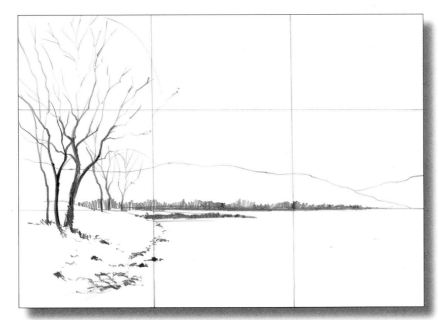

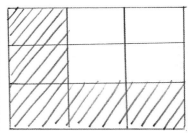

Diagram 2

It is a good idea to train yourself to consider these compositional points when you are taking photographs, but remember that the photograph is only the starting point and you can make compositional alterations when you come to draw the scene ready to paint it.

Masking detailed objects

This only applies when the detailed object, such as the farm gate shown here, is lighter, or part of it is lighter, than the colours behind it.

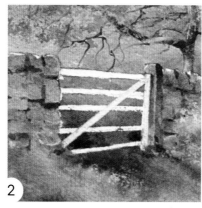 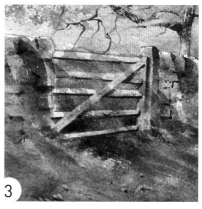 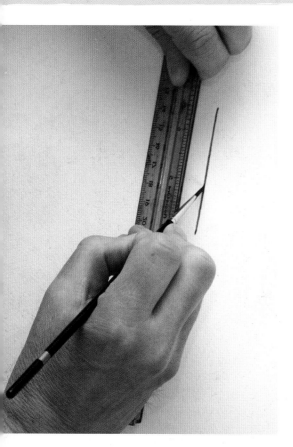

1

Draw the scene in pencil and carefully mask out the shape of the gate with masking fluid. Allow to dry.

2

Paint the background and surroundings as though the masked shape isn't there. It is important at this stage to ignore the masking; you don't need to paint carefully around it, as this is the point of masking it out.

3

Once the surrounding paint is dry, remove the masking fluid with a clean finger. Now you can paint the gate.

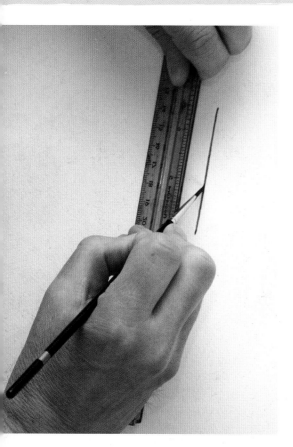

Straight lines with a brush and ruler

This method is very useful for boat masts as in the Evening Light painting on page 21. It is also useful for telegraph poles and for railings as in the Mediterranean Street Café painting on page 77.

You need to use a small brush with a very fine point, but a rigger is not suitable as the longer hairs make it too flexible. In the illustration I have used a number 2 round.

It is vital when running the brush along the ruler that the ferrule of the brush, and not the hairs, rests on the ruler. In order to achieve this, I hold the ruler with my left hand above the area I am painting, using my fingers under the edge of the ruler to raise it off the paper, leaving my right hand free to hold the brush.

I find I get a much straighter line if I paint it with a quick stroke; the more slowly you move the brush, the more time you have to wobble or shake.

Using wax resist

I find this is a good technique for depicting light reflecting off the surface of a body of water, especially if that surface is slightly disturbed. I start by using a piece of wax from a candle or tea-light. A tea-light is particularly useful, especially if used on its side, as it is not too big or clumsy. This technique is used in the River Bridge painting on page 113.

1

Rub this along the surface of the paper in even, horizontal strokes. It is vital that these strokes are totally level as of course water always finds a level, and any slopes or angles in the brushwork here would not read as water. I find the best paper for this is a Not surface watercolour paper, as a Rough paper can break up the wax deposits a bit too much.

2

The next stage is to brush the colour horizontally across the waxed area. This only deposits paint on the areas of paper where there is no wax, because the wax resists the water. These waxed areas remain white to give the effect of glistening light.

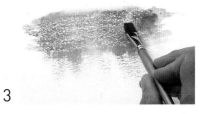

3

The final step is to use a flat brush – I usually use a 10mm (3/8in) brush – to blur the still damp paint horizontally, which gives the appearance of reflections.

Birches

This technique for painting silver birches was used in the Hamlet Bridge painting on page 105.

For this row of birches, depicted at the edge of a forest, I applied masking fluid to the long, thin trunks, using a fine brush to ensure they did not look too thick and clumsy, before painting in the background. When the background had dried, I put in a very thin mix of burnt sienna and raw sienna to represent the tops of the trees and fine tracery of branches. When suggesting the fine branches in this way, ensure that the wash is very thin and use the dry brush technique. Once the masking fluid was removed, I coated one trunk with clean water before dropping in some patches of a rich dark brown made from burnt sienna and French ultramarine. I allowed this dark to soften into the wet background without spreading too far, thus leaving plenty of white paper still visible. It is important when working with this technique to focus on just one tree at a time, otherwise the clear water will dry before you have time to drop the dark brown into it. To finish off the birches I used a fine no. 2 brush to put in the very fine branches with the same dark brown mixture. I also painted a few light coloured branches with a mixture of white gouache and burnt sienna. To make the marks on the trunks look convincing, it is important to get that slightly blotchy, random look.

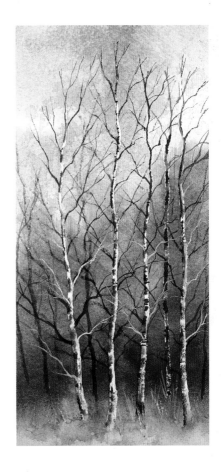

Lake in Spring

Early spring is an excellent time of year to get out and about looking for potential painting subjects. I particularly like the way the trees are still in their winter form, allowing the viewer a clearer, less obscured view of the landscape than in mid-summer, when often the masses of foliage can hide important detail. I also like the hint of colour provided by the buds forming on the trees, and the green shoots sprouting from the ground around the hedgerows, verges and pastures.

One of my favourite places to visit at this exciting time of year is the Lake District in the UK, which over the years has provided me with plenty of inspiration and subject matter.

I came across this scene while walking from Keswick to Ashness Bridge on a terrace path which afforded marvellous views of the hills on the opposite side of Derwentwater. I find this sort of subject lends itself particularly well to a more panoramic shape, where the length of the painting is twice the height, as opposed to the more traditional format where the length is more like 1.5 times the height.

In order to give myself plenty of information, I took three separate photographs, which I printed and taped together once I was back in the studio (see below). I realise that there is some very clever software available that I could use to connect these seamlessly; but as the photograph is not an end in itself, just a source of information, I am happy to just use clear adhesive tape. This gives me the advantage that, should I want a really large reference to work from, I could tape three A4 (letter-sized) prints together. Usually though, I find A5 big enough.

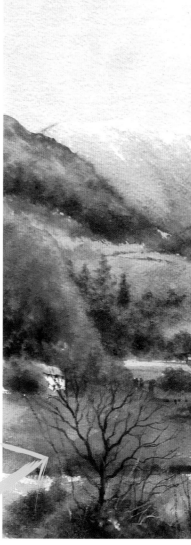

The finished painting

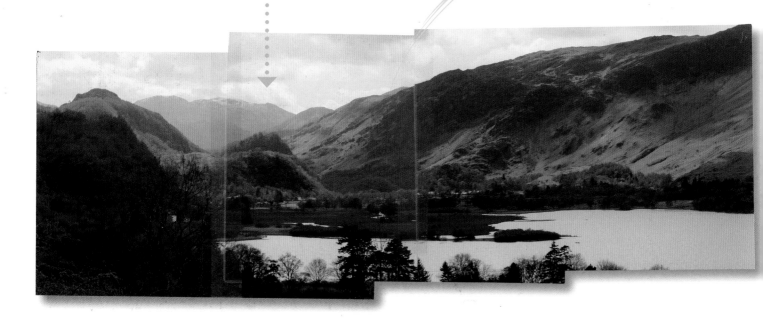

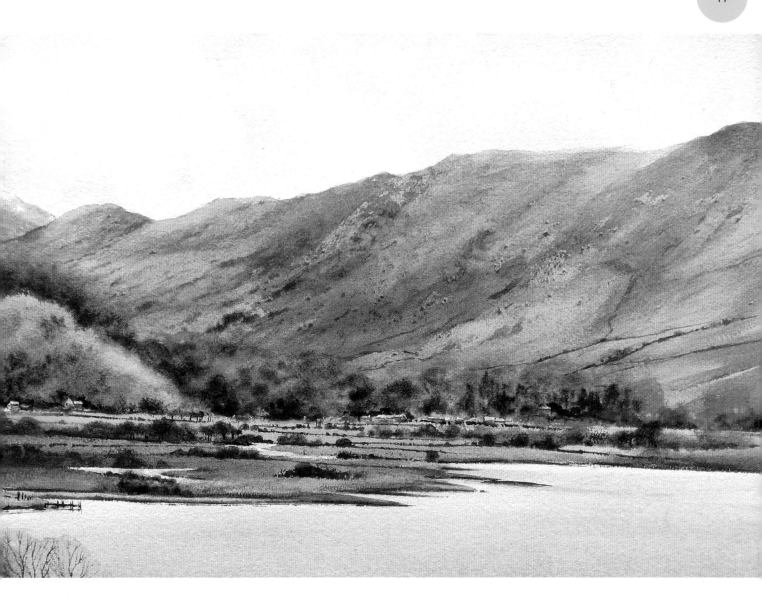

Before drawing the basic shapes and composition on to watercolour paper for the actual painting, I did a quick pencil sketch (right) on a separate piece of cartridge paper. This is mainly to give me a feeling for the subject, but also it is a good opportunity to practise drawing. Time spent drawing and sketching in this way, using just a pencil or graphite stick, is never wasted, as it hones your drawing skill and increases your familiarity with the subject.

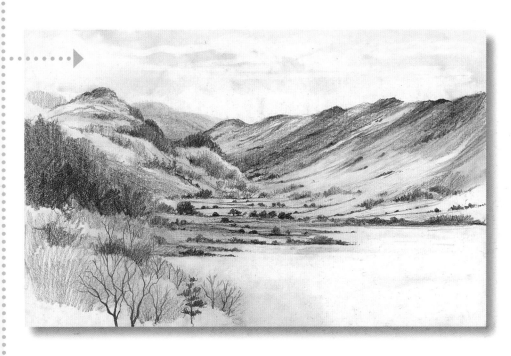

If you compare the finished painting (shown again, opposite) with the photograph (below), you can see that I cropped it a bit at both the right and left-hand sides to reduce the overall length. This also removed the heavy dark area on the left which I felt was a bit dull. If you look at the detail from the photograph (right) you can see that there is another dark, heavy area. Compare this now with the same area in the finished painting (below, right), and you can see how I have lightened this, replacing the dark browns and greys with a lighter green and just a hint of red.

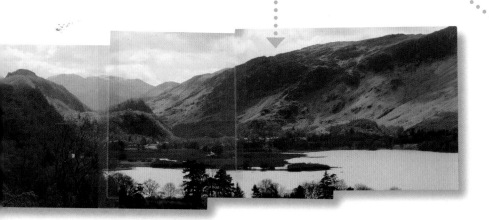

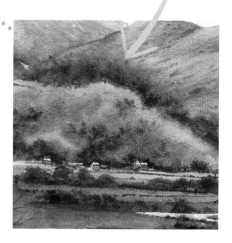

I also felt that the whole central area of the distant hill being under a dark cloud shadow (see left) did not have enough light or colour in it for such an important passage of the painting. I therefore lightened this whole section by observing the detail of the hills and slopes at the far right of the photograph (see below) and bringing them across to the centre. Indeed I felt that all the cloud shadows were a little grey so I used a more purple-grey mixed from cobalt blue, rose madder and light red.

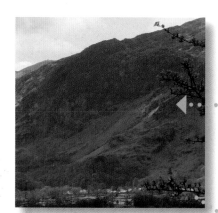

I felt that one of the most attractive passages of this scene was the bright sunlight on the flat meadows at the base of the hill, so I extended this area slightly, ensuring that I used a bright spring green sandwiched between the darker colours to provide contrast.

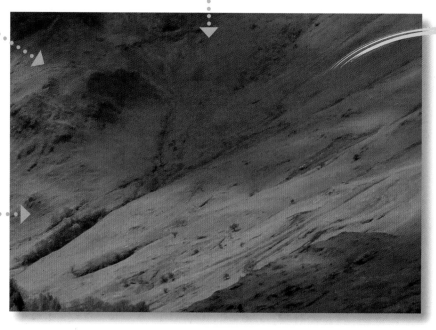

Colour mixes

Purple-grey
Cobalt blue, light red and rose madder. Used in the sky and for cloud shadow on the distant hills.

Red-brown
Burnt sienna and rose madder with just a hint of cobalt blue used sparingly in the tree foliage and the marshy land in the distance.

Dark brown-green
Aureolin, French ultramarine and burnt sienna. A dark tree green.

Dark green
Viridian, French ultramarine and burnt sienna. A dark green, especially good for fir trees.

Bright green
Aureolin and cobalt blue with just a touch of raw sienna. Used for the brightly lit fields and the top of the tree-clad hill on the left.

Finally, I had to make a decision about the foreground of the painting. On the photograph, you can see that I am actually looking over the top of a line of trees at the very bottom of the scene. You could argue that these help to create distance and frame the scene, but I decided that rather than enhancing the picture, they acted as a barrier, so I decided to leave just a few trees in at the very bottom left, which still benefited the composition without detracting from it.

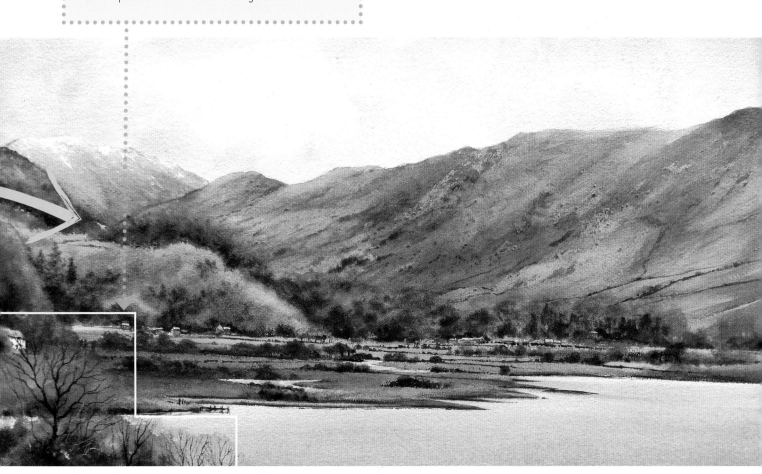

Evening Light

What shall I paint today? This is the question I find I often ask myself when I am working towards an exhibition and have to produce maybe thirty new paintings. It is important to me to have plenty of new material gathered from walking trips and holidays, and it is vital that the subject excites me and inspires me to pick up my brushes and set about the project with enthusiasm.

It sounds like a cliché, but I feel I produce a much better piece of work when it is something I really want to do, as opposed to just a subject I feel will be popular, or has a good chance of selling.

Sometimes though, if I can't get the inspiration, I find it is worth trawling through old photographs, looking for something I never got round to painting or somehow missed. It was on such an occasion that I found this old photograph from a holiday in Norfolk, UK, many years ago.

It was only a small 15 x 10cm (6 x 4in) photograph, printed before the digital age, from a long-lost negative, so I couldn't reprint it larger to get a tidier copy and to provide more information. In a way, however, that was an advantage, because this scene is really inspired by light, with many of the shapes silhouetted and detail not clearly defined. It also is taken looking into the light or *contre jour*, an effect I love to try and capture.

I took a few minutes to study the scene and think about my approach, deciding to give it a slightly un-resolved hazy look, particularly in the distance. I thought this would help to capture the feeling of a warm sunny, summer evening, bathed in a fading light.

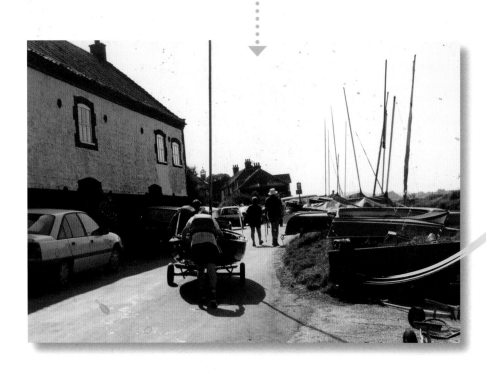

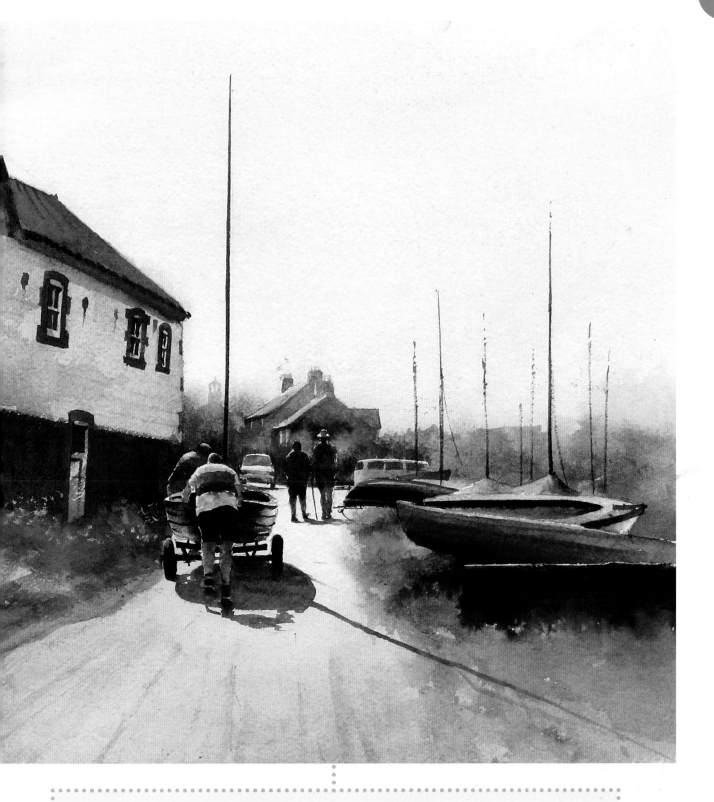

In the finished painting, I simplified the boat shapes to cut out some of the clutter. I removed the two cars on the left, but left in the white one in the distance. I like to include cars in a painting as they are very much part of our lives and it would be unusual to find a scene like this without any. I also think they can introduce a bit of contrasting colour and shape. In this instance I thought the car helped with the viewer's progression through the picture, starting with the guys pushing the boat, to the two walkers, then the contrasting shape of the car which leads the eye to the pitched roofs of the cottages and finally the very soft, hazy shape of the little tower. Tonal values are very important here; observe how faint the shape of this tower is compared to the parts of the painting nearer the foreground.

I felt that the focal point – and indeed the main thing that attracted me to the scene - was the men pushing the boat, with the fleeting sunlight just catching their backs as they put all their efforts into moving the heavy object. Because it was vital to get this part to look convincing, I did a small pencil sketch (see right), taking time to make the shapes look believable. Having satisfied myself that the little sketch was all right, there was no need to draw it all over again on to my watercolour paper – I just traced it (see far right). I don't see this as cheating, as after all it is my own sketch I am copying.

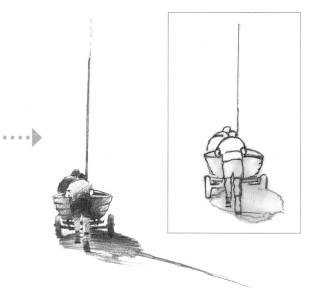

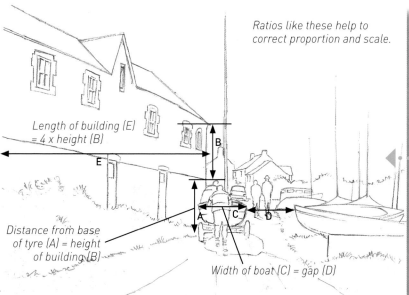

Ratios like these help to correct proportion and scale.

Length of building (E) = 4 x height (B)

E

B

Distance from base of tyre (A) = height of building (B)

A C D

Width of boat (C) = gap (D)

Once this was traced on to the watercolour paper, I worked outwards from it to draw in the rest of the scene. I used some simple calculations to ensure I got the proportions correct; for example I determined, using a ruler, that the distance from the shoulder of the man in the red top to the edge of the roof, was the same as from his shoulder to the bottom of the left-hand boat tyre. I used many similar calculations to plot the whole scene, making this type of comparison, as shown in the diagram.

If you further compare the photograph with the painting, there are other small changes I have made to enhance the scene. I made the roofs of the distant cottages lighter and a bit redder to give the impression that the light was reflecting from them. If you look at the detail from the photograph (right), the windows appear quite modern. Compare this with the detail from the painting (below right) and you can see that I have depicted them as more traditional sash windows with a definite recess. I have no way of knowing if the original windows were like this, but I think it reads well and is quite believable. I put the weeds and grasses around the base of the building (using a bit of imagination as this area was obscured by cars), to provide a contrast of soft shapes.

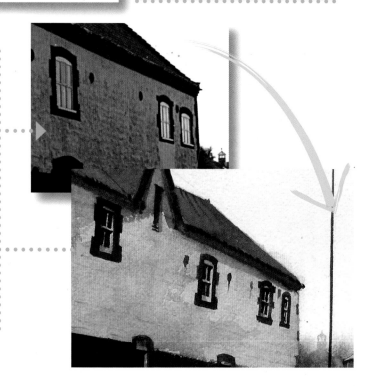

Colour mixes

Sky

Three thin washes were brushed into the sky to create a warm glow:

Pantile roofs

Quinacridone gold

Rose madder

Cobalt blue and
rose madder

Quinacridone gold and
burnt sienna

Green for grasses, weeds and bushes

Quinacridone gold and cobalt blue

Dark for building

The dark brown used for the lower half of the building on the left is mixed from French ultramarine and burnt sienna with a few touches of neat lemon yellow and Naples yellow to suggest grasses and weeds.

Bright highlights, like the walker's hat, the top edge of the little wall in the bottom right and the vehicle roofs are very important as they help with the *contre jour* effect; so I protected these areas with some carefully applied masking fluid.

For instructions for painting perfectly straight boat masts with a brush and ruler, see Painting techniques on page 14.

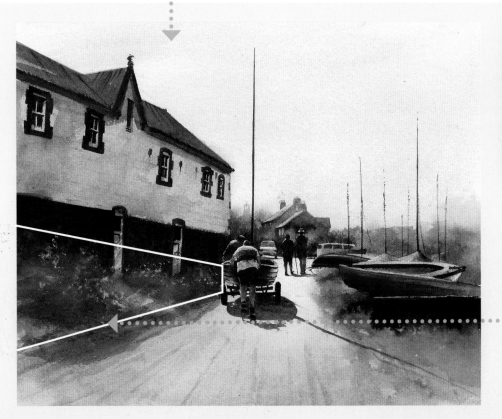

I put the weeds and grasses around the base of the building (using a bit of imagination as this area was obscured by cars), to provide a contrast of soft shapes.

Hillside Village

If I really like a subject and am pleased with the way the painting turns out, I will often want to paint it again at a different time of year, so I can reflect how the change in season has altered the scene. Sometimes it is possible to use your imagination, for instance using a photograph you took in spring and trying to imagine what it would look like in autumn or winter; but here I have two photographs of the picturesque Derbyshire village of Rowsley, one taken around March (below) and the other in deep snow in January (page 28). This is also something I try to engineer by going back to a favourite holiday location at a different time of year.

If you compare the photograph below with the finished painting, you can see that I have made very few compositional changes; painting the scene almost exactly as it is in the photograph with very little moved, deleted or added. That is simply because I liked it just the way it was. I did however want to employ a bit of artistic license with the colours (see Colour mixes, page 27).

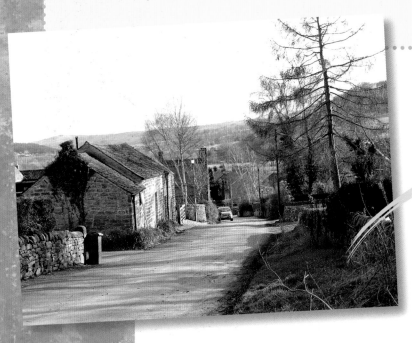

I kept the car in the scene: if you compare this with the car in the photograph (see detail), you can see how I have painted it carefully, ensuring that the shape is believable. Just as you have to make boats in coastal scenes look as though they could float, a car has to look as though you could get in and drive it. At the same time though, you need to leave some areas of white paper in the bodywork to make it appear shiny.

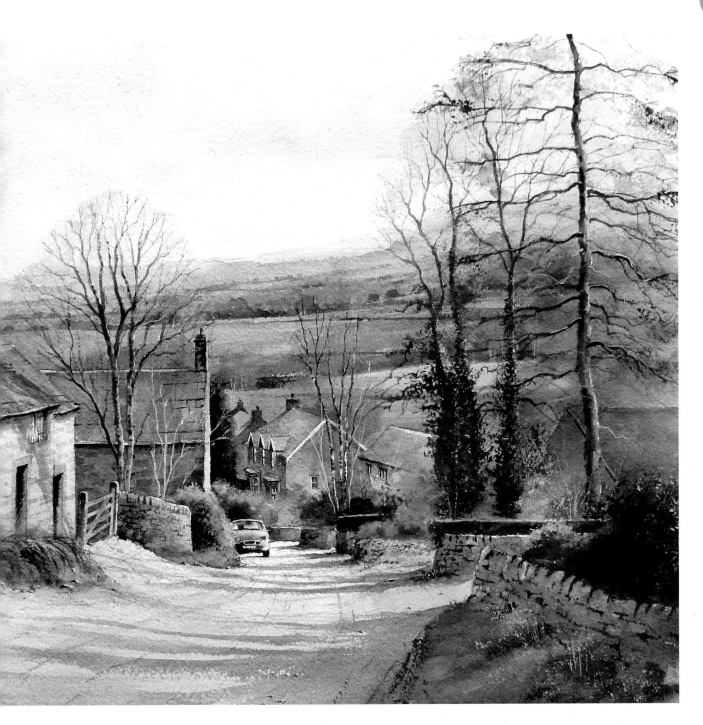

In the foreground barns on the photograph, you can make out every stone and mortar detail of the stonework; but in the painting, rather than painstakingly rendering all the stonework, I have suggested it with a few rectangular marks. The dry-stone wall in the left-hand foreground has been left slightly unresolved near the ground, to give it a more painterly, less detailed rendering. However, I painted the grasses at the base of the barn wall more carefully (see detail) as I liked the curved shapes created by the way they bent over. It is a good idea to contrast detailed, more carefully painted areas with less resolved, looser areas.

As for the waste bin in the photograph that I have excluded; when the painting was framed and on my gallery wall, I wished I had included it.

Compare the greens on the distant fields in the photograph with the painting; here I used a touch of lemon yellow to give them more vibrancy. You have to use this very sparingly or it can look a bit acid. I was careful not to overdo the brighter greens, still softening them into a grey/purple colour for the most distant part of the landscape.

Next, compare the grey shadows in the photograph (both on the wall of the nearest barn and across the road in the foreground) with the warmer, richer shadow colour in the painting. I achieved this by putting plenty of cobalt blue into the cooler shadows, but reddening this with rose madder and a touch of light red in the foreground shadows, which warmed the colour, making it appear nearer.

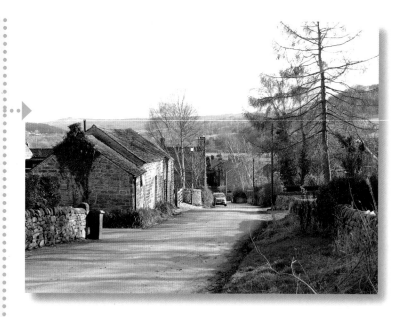

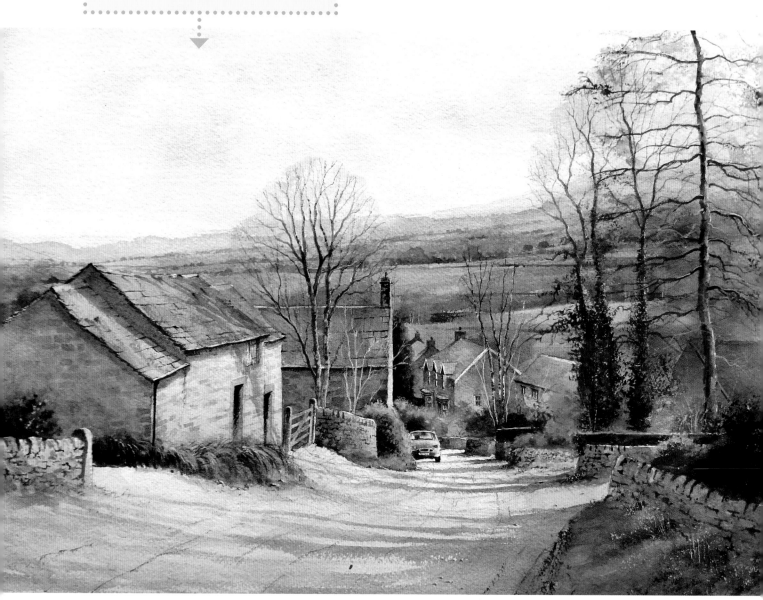

Another area where I significantly increased the vibrancy of the colour is on the gable wall of the cottage in the middle distance (see detail). In the photograph this is a sort of grey-brown, whereas in the painting I have used an almost orange colour made from raw sienna and light red. I felt that this served to accentuate that particular part of the scene, making it a focal point, which hopefully would draw the viewer down the road, immediately involving them in the painting.

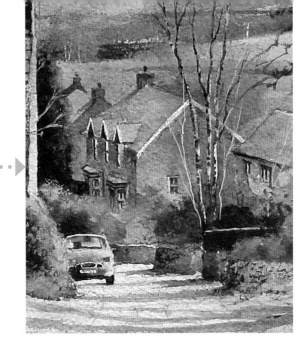

Colour mixes

Cool shadow colour
Cobalt blue and a touch of light red

Warm shadow colour
Cobalt blue, rose madder and light red

Sunlit stonework
Raw sienna and light red

Dark green
Viridian, French ultramarine and burnt sienna

Sunlit fields
Lemon yellow with a touch of cobalt blue

Red-brown
Quinacridone gold and burnt sienna

Mid-brown
Burnt sienna and cobalt blue

Dark brown
Burnt sienna and French ultramarine

Stone colour
Raw sienna and burnt umber

The same scene in winter

When I photographed the scene again on a bright winter's morning, I knew immediately that this would make a painting at least as good, if not better than the one in March. I couldn't wait to get home, print the photograph and get started. I chose to move in a bit closer this time, making the buildings larger and more dominant. I should at this point explain why I did this, but the truth is it just felt right on the day. If you have an instinct for what will make a good scene when you are planning a painting, I think you should go with it. When you are revisiting a scene, it is particularly important not to consider how you did it last time: this will ensure you are creating a fresh piece of work. I have sometimes tried too hard to recreate a painting I was particularly pleased with, only to fall short, producing something perfectly acceptable, but lacking that vital spark.

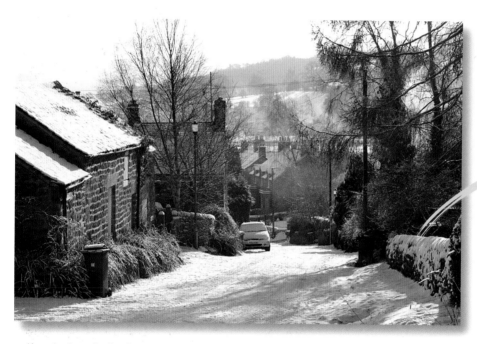

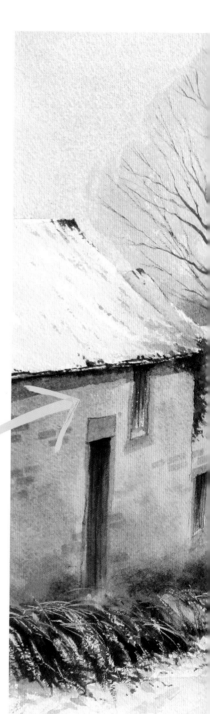

If we look at the basic changes I have made between photograph and painting, you can see that again I left the composition more or less unchanged, but spiced up the colour a bit, adding a few more reds and browns where the photograph was predominantly grey.

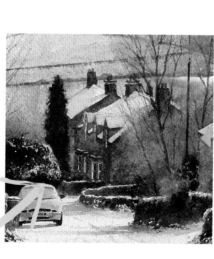
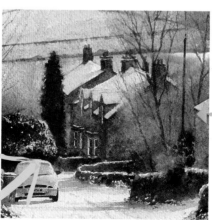

If you compare the details from the photograph and the painting, you can see that I tried to retain that soft, misty look around the gable of the cottage, with a slight lost and found effect along the edge of the roof.

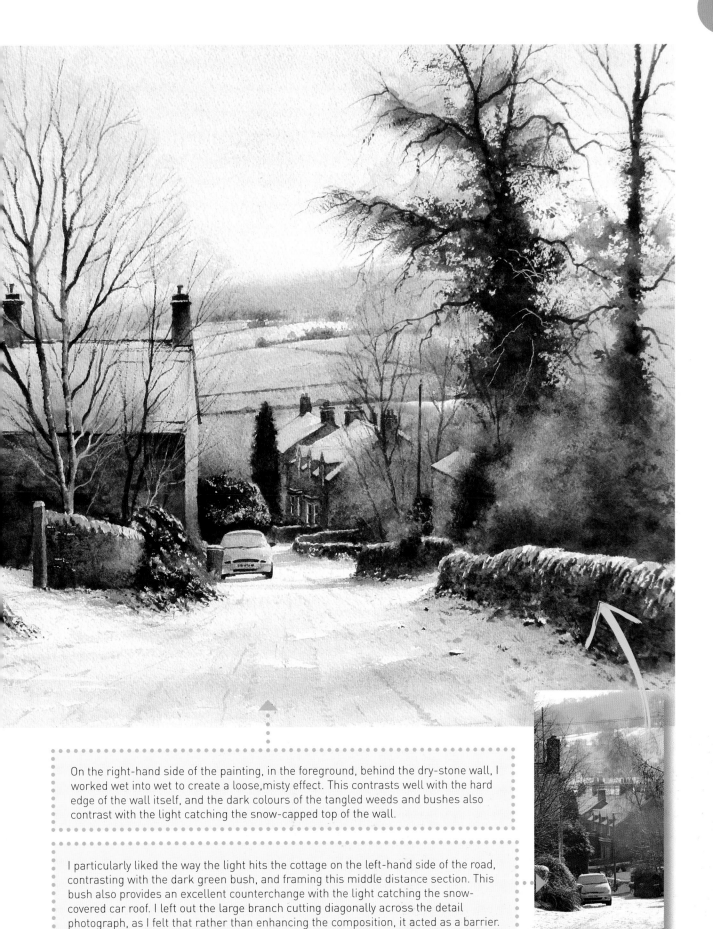

On the right-hand side of the painting, in the foreground, behind the dry-stone wall, I worked wet into wet to create a loose, misty effect. This contrasts well with the hard edge of the wall itself, and the dark colours of the tangled weeds and bushes also contrast with the light catching the snow-capped top of the wall.

I particularly liked the way the light hits the cottage on the left-hand side of the road, contrasting with the dark green bush, and framing this middle distance section. This bush also provides an excellent counterchange with the light catching the snow-covered car roof. I left out the large branch cutting diagonally across the detail photograph, as I felt that rather than enhancing the composition, it acted as a barrier.

London Park

I took this photograph while walking through St James's Park in London on a bright November morning. It is not difficult to see what I liked about the scene; with the strong sunlight, the rich reds and yellows of the autumn foliage, and the bustle of people going about their business

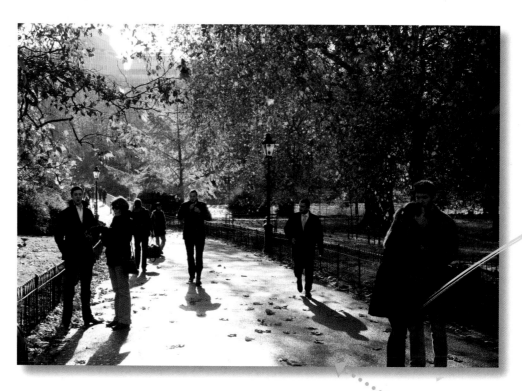

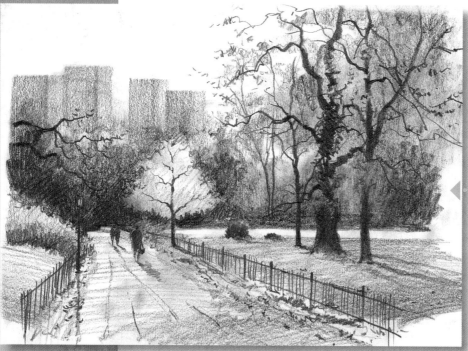

I did a quick value sketch in pencil to get a feel for the subject and establish the main tonal values.

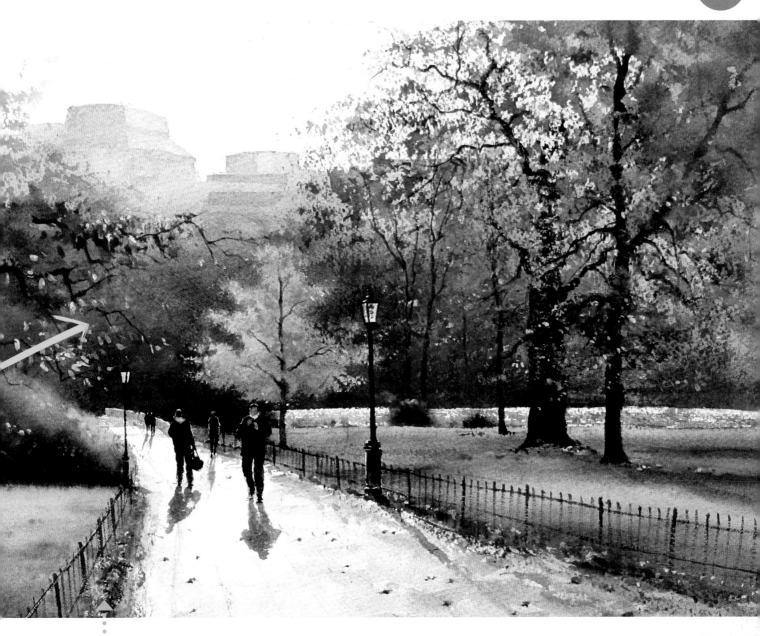

I chose to look into the sun to provide the strong contrast of dark against light; I also liked the way this backlit the golden-coloured tree, giving it a strong glow. Looking into the light in this way just catches a thin line of light on the top of the heads of the silhouetted figures, suggesting their form against the dark background.

I decided that even though the figures were an important part of the scene, I didn't want to include all of them; preferring instead to pick and choose. If you compare the original photograph with the painting, you can see that I have excluded the ones nearest to the foreground, preferring to put the figures in the distance and middle distance. This way you avoid having to include details like facial features, which are very tricky to get right.

I felt I had got the composition more or less correct at the photography stage, and didn't need to make any changes, but there were many alterations and interpretations I did need to make to develop this promising photograph into a finished painting.

If you compare the detail from the photograph (right) with the detail from the same area of the painting (far right), you can see that in the photograph this is very dark and lacking in interest, but in the painting I have made it much lighter, with branch and leaf detail more visible. I mixed watercolour with gouache to create an opaque colour to use for the leaves, where they are contrasted against the dark of the tree trunks.

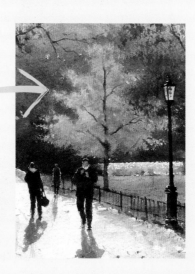

I felt that the focal point of the whole scene was the triangular-shaped tree left of centre (see far left), so I deliberately gave the shape more definition and increased the tonal contrast by lightening the tree, making it even more punchy against the dark background. The best way to do this was to mask the shape of the tree with masking fluid, before painting in the background. If I had just applied the masking fluid to dry paper, the tree would have looked lumpy and hard-edged, so I wetted the whole area, going beyond the size of the tree itself. If you don't do this, the masking fluid, when applied, will reach the edge of the wet area and stop, creating a hard edge, which is the very thing you are trying to avoid. I then painted the shape of the tree in masking fluid, allowing it to spread gently, creating a soft, slightly diffused shape more reminiscent of foliage. Later on when the background had been painted in and allowed to dry, I just removed the masking fluid and brushed in the tree colour with light washes of yellow and orange (see Colour mixes, opposite). Only when this had dried, did I put in the suggestion of trunk and branches. See Applying masking fluid to a wet background, page 11.

The brilliance of the light on the metalled path was very important to the painting, so I simply left most of it as white paper, just using a few touches of grey shadow where appropriate. This is more difficult than it sounds, because there is always a temptation to put in a few strokes of colour; but any paint added to the path, regardless of colour, would inevitably darken it and reduce the contrast. I also left a thin strip of white paper to represent the light catching the water along the bottom third of the scene; before tinting it slightly with some grey using dry brushwork; this toned it down slightly so it didn't compete with the path, and at the same time created a slightly sparkling effect.

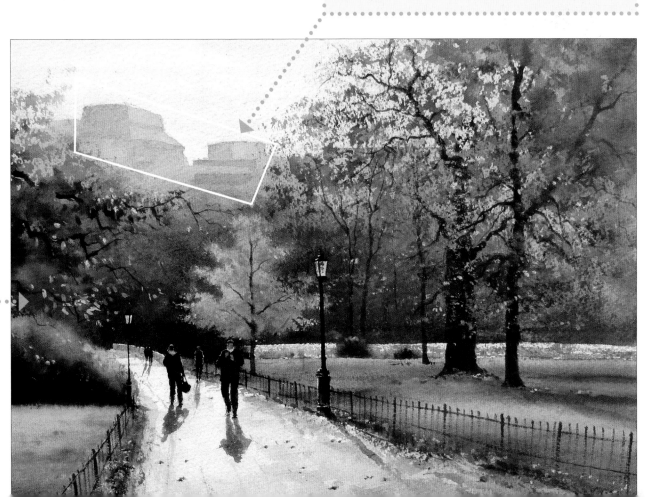

The foliage of the trees (see right) was dry-brushed in very quickly, so as not to overwork it. I used dark green and yellow-orange.

Colour mixes

Warm grey for distant buildings
Cobalt blue, rose madder and burnt sienna

Autumn yellow
Naples yellow and lemon yellow

Autumn orange
Indian yellow and burnt sienna

Cool shadow colour
Cobalt blue and burnt sienna

Dark green background
Viridian, French ultramarine and burnt sienna

Opaque foliage highlights
White gouache and Indian yellow, white gouache with lemon yellow and white gouache with burnt sienna

I merely hinted at the distant buildings with blocks of warm grey, without detail.

Summer River

Borrowdale is my favourite part of the Lake District, and over the years has provided me with numerous painting subjects. Of all the scenes I have painted in this area I think I have been inspired to paint this one the most. I love the shape of the bridge, its setting beneath the hills and the reflections in the slow-moving water of the river Derwent. The subject varies enormously according to the time of day and time of year. Here we are viewing the scene mid-afternoon on a hot August day, with the sun high in the sky, catching the tops of the trees and bridge and making these details stand out against the contrasting shadowy background of the hills.

Having walked around the subject a few times, composing the picture in the camera viewfinder, I decided that the best approach was to take several photographs that I could pick and choose from back in the studio; combining the best aspects of each one to produce the composition I would be most happy with. The reason I chose to do this was because I couldn't find just one viewpoint with every element in place.

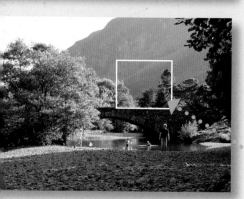

My preferred photograph was the top one, because I loved the way there was no sky in the background, rather the backdrop was created by the soft, indistinct, shadowy shapes of the hills, contrasting with the sunlit highlights of the tops of the trees in the middle distance. However, as you can see, from this angle, the large tree on the left obscured more than half of the bridge.

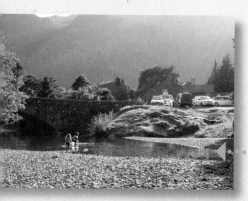

In the second photograph, you can see that by changing my position, I now got a much clearer view of the shape of the bridge, including the ellipse of the arch. From this angle, however, there was more sky exposed in the top left, (which I didn't want) and the heavy shape of the tree on the right, which obscured the view of the little cluster of buildings and parked cars. This didn't matter because of course I had that information in the first photograph.

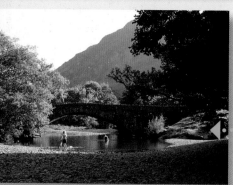

The third photograph provided me with more detail of the cluster of trees on the left and brought into view a tree with a hint of red (see detail), which I thought was important to break up the masses of green.

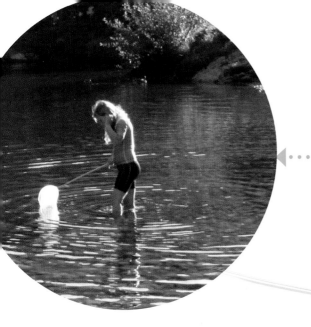

To provide a touch of narrative, I wanted to include a figure in the composition and chose the girl paddling while holding a fishing net. I particularly liked the way the sun caught her hair, and the cerulean blue of her top gave me a real contrast with all the surrounding natural colours.

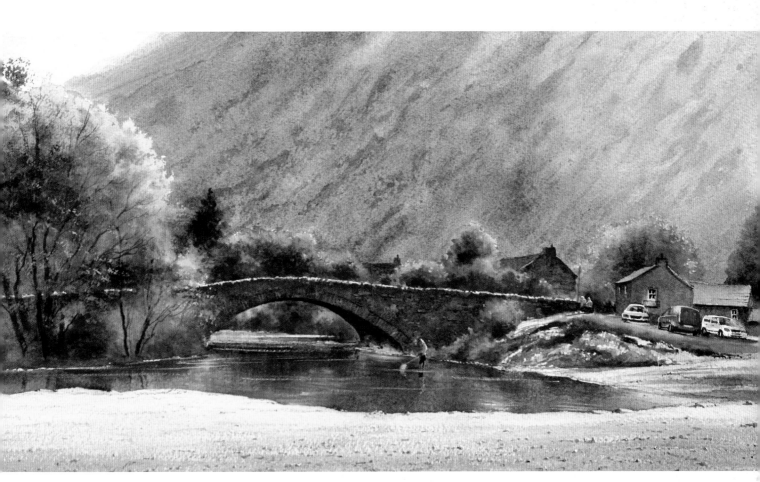

You can see from the finished painting below that all these elements were then brought together to create the final composition I was looking for. You may think that this is a rather contrived way to work, because the actual view is not possible to achieve by standing in one place. That is certainly a valid opinion, but I always believe the end justifies the means, and the finished painting is what counts. I felt in this instance that despite the few liberties I had taken, the finished painting still looked very much like the actual place.

How many times does the arch at its widest point divide into the total length of the bridge?

Check the depth of the stonework at this point and compare it to the height of the arch.

Carefully observe the curved shape of the bridge.

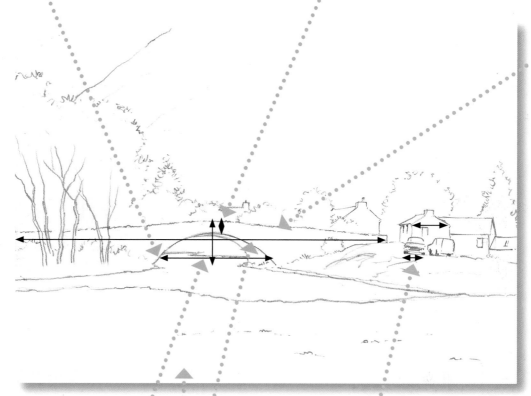

Check how many times the total height of the bridge goes into the total length.

Carefully observe the ellipse shape of the arch.

Compare the width of buildings and cars with the total length of the bridge.

In a scene of this type, with an architectural detail like the bridge, you can only take artistic license so far; and in my opinion the shape and structure of the bridge has to be accurate and credible. To help achieve this, I did a small pencil line drawing to help me to establish in my mind the shape and proportions of the bridge and its position in the landscape, before committing it to watercolour paper. I used a ruler to compare measurements, asking myself: how many times did the height of the bridge divide into the length? How deep was the stonework above the arch? How many times did the length of the buildings on the right divide into the length of the bridge?

Don't worry if by the time you are ready to start the painting, you have done quite a bit of drawing, rubbing out, and re-drawing: I do it all the time and see it as part of the process.

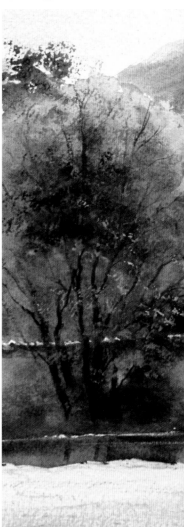

Colour mixes

Hills background colour
Naples yellow and burnt sienna

Hills green-grey
Viridian and cobalt violet

Violet grey
Cobalt violet and viridian (with more cobalt violet than the hills green-grey mix).

Bridge stone colour
Naples yellow and burnt sienna with a touch of raw sienna and cerulean blue brushed in wet into wet.

Bridge glaze
When the bridge stone colour wash had dried, I glazed it with a wash of cobalt blue and rose madder.

Bridge details
After allowing the bridge glaze to dry, I added dark details in burnt sienna and French ultramarine to suggest the gaps between stones, plus a few strokes of neat Naples yellow to suggest the stones themselves.

I used masking fluid applied on a wet background (see Painting techniques, page 11) to create the soft, brightly lit tops of the trees against the darker colour of the background hills. I also used masking fluid along the top of the bridge to give me the thin line of bright light, and on the roofs of the buildings and cars on the far right. The reflections were dragged down in the water area while it was wet, with a 13mm (½in) flat brush.

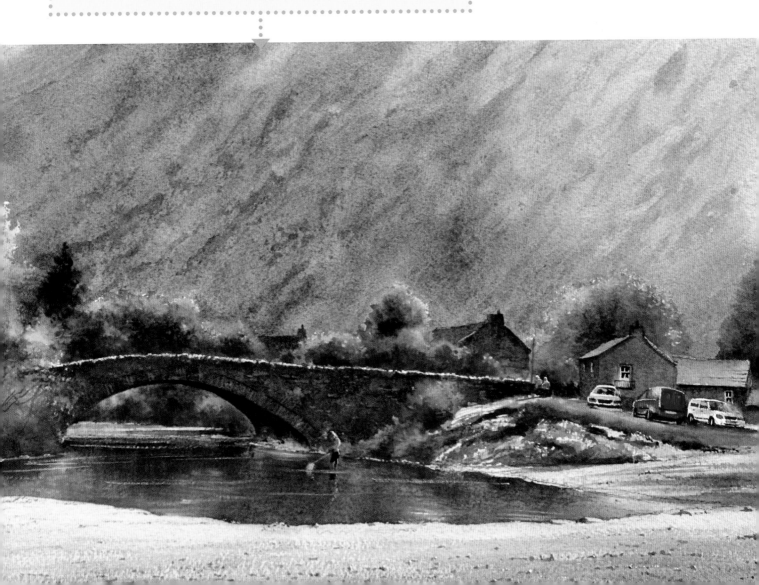

Loch Ness

I found this scene when my wife and I walked the Great Glen Way from Fort William to Inverness in Scotland, in 2013. Day four of the walk was a fourteen-mile hike, most of which ran alongside Loch Ness, and I found this view at the outset of the day's walking, on a short detour to the water's edge. I was inspired by the early morning mist on the loch that shrouded the distant hills, giving just a few glimpses of the tops here and there, and leaving an indistinct line where the land meets the water. This was further enhanced by the bright sunlight breaking through the clouds and reflecting on the surface of the water at the right-hand side.

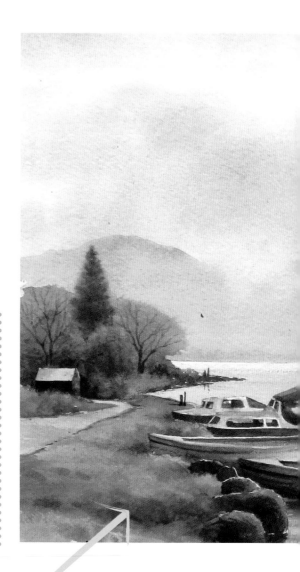

I decided there and then that this would make a good painting subject, but I knew that to do the scene justice, the painting would need to be long format, so I took several photographs that I later printed out and taped together. Although this panorama gave me plenty of information and a feeling of the scale of the loch, I felt that it was too long for a painting, the length being four times the depth. It is possible to paint something in this format but my instinct was that it would just be too long, without much interest in the middle. I also thought that while the peninsular on the right was an important element in the composition, I didn't need quite so much of it, so I was able to further reduce the length by shortening this detail. Of course this type of decision is personal choice and you the reader may see it differently, but I felt I was still able to convey the big open space, despite reducing the length.

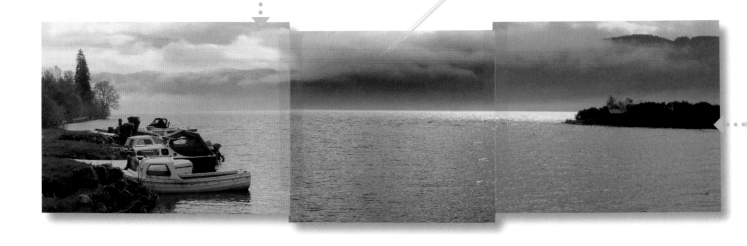

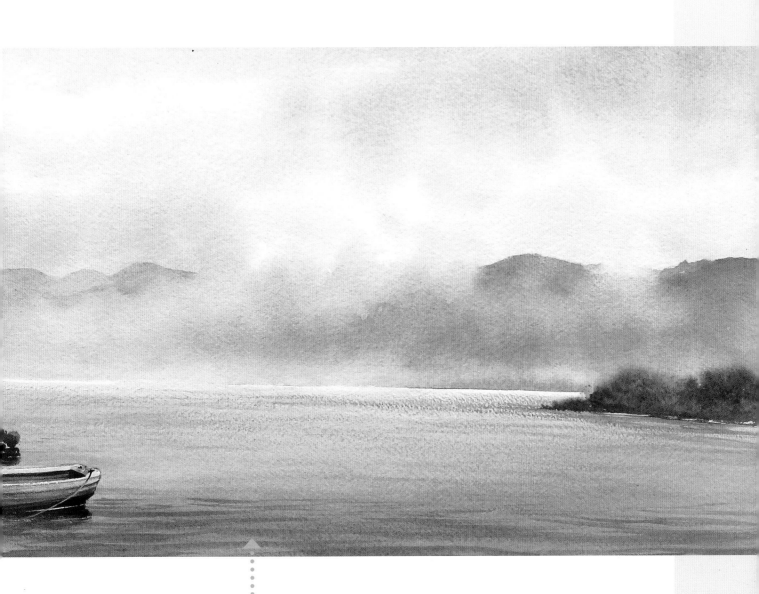

If you compare the photographs with the completed painting above, you can see that in the photographs, the horizon is just above halfway up the paper, whereas in the painting, I have lowered this to about a third of the way up. This improves the composition, as it complies with the rule of thirds (see Composing from photographs, page 13). It also gives me more scope to get stuck into the clouds, mist and hills, which is really what the scene is all about. At the right-hand side, I have lightened the scene, allowing a bit more of the shape of the hill to show through the mist.

If you compare the detail of the photograph with the detail of the painting, you can see how I lightened and added more colour to the peninsular, which was a very dark silhouetted area without much interest.

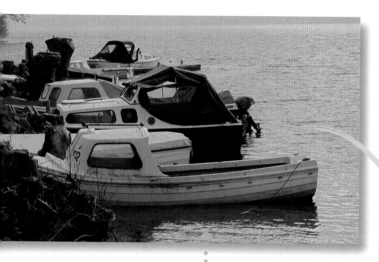

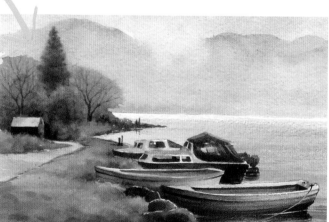

If you compare the boat area in the photograph and painting, you can see that I made a few changes here, cutting out the large tree stumps and simplifying the structure of the boats. I wanted this to be a more detailed, colourful area to contrast with the open, less colourful feel of the rest of the painting. To keep the harmony I had achieved so far, I didn't introduce any new colours for the boats, preferring to stick with the same blues and greys. It was also important to consider that the boats are much nearer to us and not affected by the mist in the background. With this in mind, I made them look much sharper, taking care not to allow the colours to bleed. Finally, at this far left-hand side of the scene, I felt I needed a bit more interest, so I put in a winding path leading to a small boathouse. This also serves to lead the viewer's eye into the scene.

Colour mixes

I mixed four washes for the sky. It was essential to have all these colours ready before wetting the background, so I was ready to paint as soon as the water was applied.

Sky colours

 Cobalt blue and cerulean blue

 A stronger mix of cobalt blue and light red, for a darker grey

 Cobalt blue and light red

 Naples yellow and light red

All four sky mixes floated into a wet background.

Once the sky had dried, I was ready to paint the mist-shrouded hills. This was the tricky bit! I won't pretend that this lost and found effect is easy, but it does get easier with practice. The key to it is not to try to paint the mist, but rather when the sky has fully dried, paint glimpses of the hills (the found) here and there, brushing in clear water where you don't see the hills (the lost). In effect, where the mist or low cloud obscures the hills, you are allowing the viewer to see straight through to the clouds and misty shapes previously applied in the sky stage (see Mist and low cloud on hills, page 10). It is worth practising this method on a smaller scale, perhaps with a few thumbnail trials, before applying it to your painting. Overworking is the enemy of this effect, as it is so easy to lose the feeling of light and get unsightly 'cauliflowers'.

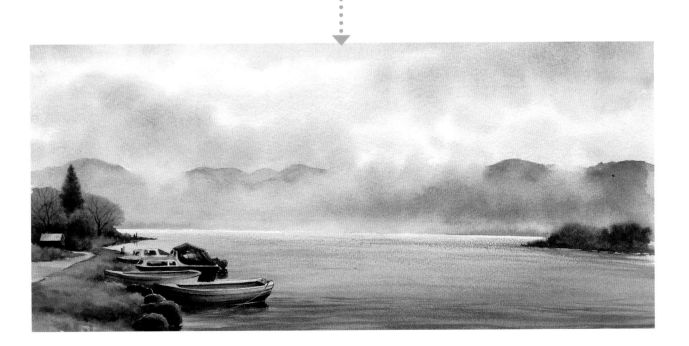

Pavilion Gardens

I took this photograph of Buxton, Derbyshire, UK, when gathering material for a calendar of watercolour paintings. It is a good example of making quite a few changes to a scene, while at the same time still retaining the elements that are its essence, and make it instantly recognisable to anyone who knows the place.

I started, as I often do, by doing a tonal value sketch in pencil. This helped me not only to establish the composition, but to explore the strong contrasts between the lights and the darks, which were particularly important as the photograph was taken on a winter's afternoon with the sun fairly low in the sky. I particularly liked the long shadows and the way the weak sunlight catches the tops of the shrubs and bushes to the right of the river.

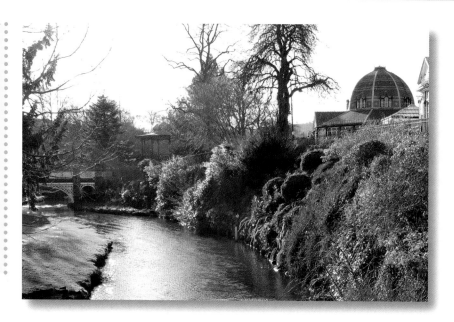

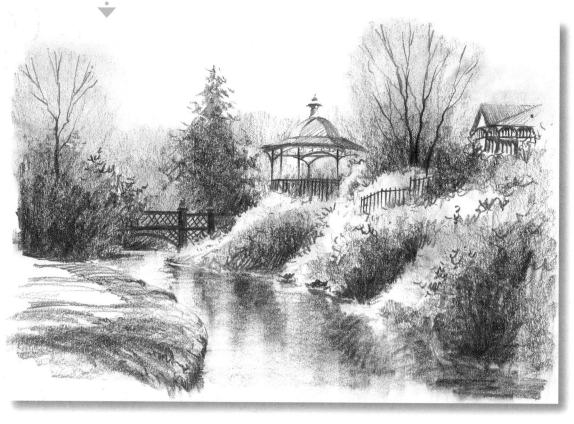

If you compare the photograph opposite to the finished painting, you can see that I didn't include the pavilion at the right-hand side, just leaving one gable showing to remind us it is there. This enabled me to close in and make the bandstand the focal point of the picture. I did this because I felt that in the photograph, the two structures competed with each other. I was particularly attracted to the wrought ironwork of the bandstand and the way the light caught the left-hand corner of the roof, reflecting on the lead covering, so decided this should be the focal point. When I am out and about with my camera, it is often small touches like this that catch my eye and give me the spark of inspiration on which I can base a whole painting.

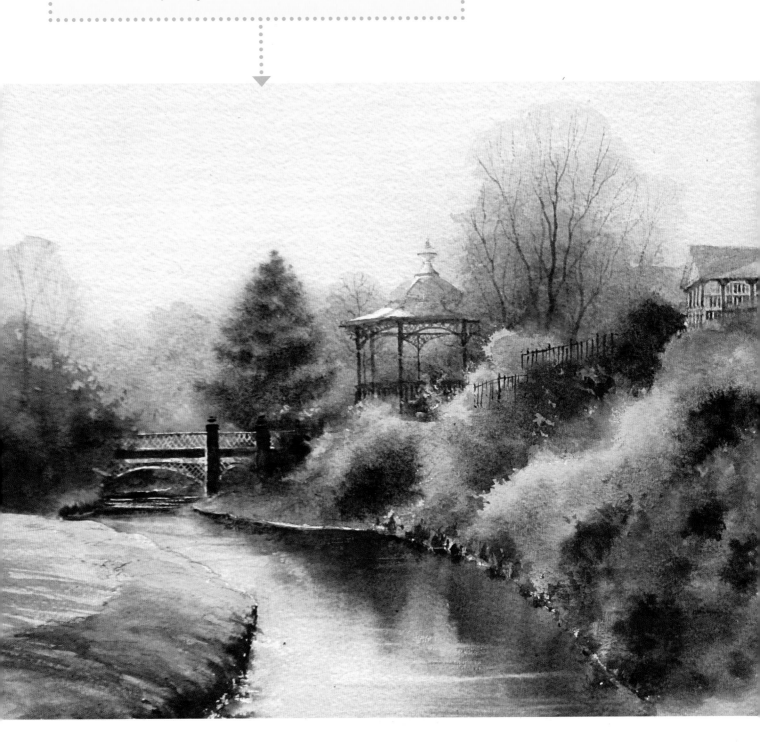

Looking at my printed photograph, the bandstand looked so small that I felt I needed more information, so I cropped it on the computer, and printed this close-up from which I could get more detail. You may wonder why I just didn't use my imagination, but when a manmade structure such as this is to be your focal point, it is vital that it looks convincing. This means that it is very important to get right details like the glimpse of the very top of the dome, the way the sun catches the left-hand side of the roof and the patterns and shape of the wrought ironwork.

When I want to crop a photograph, I don't use expensive editing software, just the basic programme that is already installed on most computers.

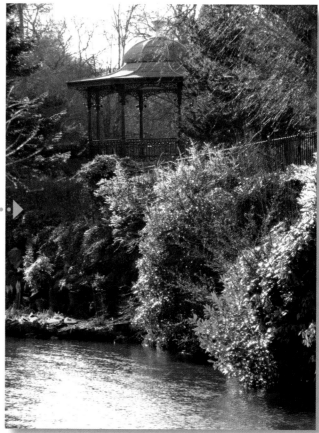

If you look at other changes I made between photograph and painting, you can see that I removed the two tall trees, (one from the centre and one just to the right of centre), that go right up and out of the top of the scene (see detail photograph). I retained the smaller tree or bush between these trees, making it just slightly taller than it is in the photograph.

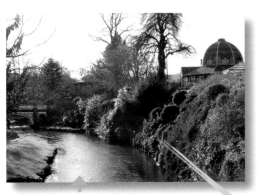

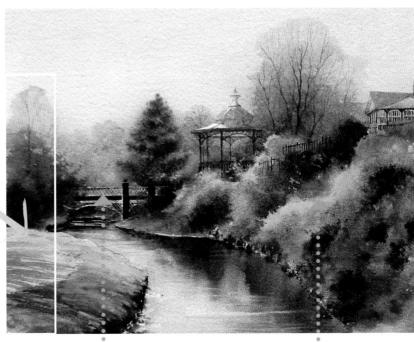

Looking at the photograph (above) again, you can see that I hadn't captured the path and bushes at the far left-hand side. I felt that without this detail in the composition, the bridge was too near the edge of the picture and it was a lost opportunity to use the track of the path to lead us into the scene. This meant I had to use a bit of imagination here, but it wasn't difficult to guess what this area could look like.

The criss-cross patterns of the bridge's structure were a bit tricky and left me wishing it had been a stone or brick structure. However, this would not have been in keeping with the very Victorian style of this place, so I decided to paint the criss-cross pattern carefully with masking fluid using a very fine, pointed brush.

Masking fluid also had a part to play in the rendering of all the shrubs and bushes at the right-hand side of the river, used on wet paper to provide soft shapes. See Applying masking fluid to a wet background, page 11.

Colour mixes

 Lemon yellow for highlights on foliage. → Add a touch of white gouache for a quieter, more opaque lemon.

 Dark blue-green: viridian, French ultramarine and a touch of burnt sienna.

 Blue-green: viridian, cobalt blue and a touch of burnt sienna. ⋯→ Add a touch of white gouache for a grey-green.

 Aureolin, cobalt blue and a touch of raw sienna. A good grass and foliage green.

 Warm shadow colour: cobalt blue and rose madder.

 Warm orange-brown: raw sienna and burnt sienna. Use sparingly as a relief from green.

Ruined Mill

I have always found the subject of ruined buildings fascinating, whether they are dwellings, mills, factories, or any type of manmade structure where encroaching nature has been slowly reclaiming the buildings and their surroundings. I enjoy the way creepers hang from the crumbling walls, and trees and bushes sprout from what once was the floor. I like to see where the stonework takes on a patina created by moss, lichens and general decay, and evidence of what once were windows, arches, fireplaces and other indications of past habitation and use.

One such place that is rich in this type of material is the Lumsdale Valley in Derbyshire, UK, and I find it usually rewards a few hours' exploration with the camera and the sketchpad. It was on one such trip that I took the photograph for this painting.

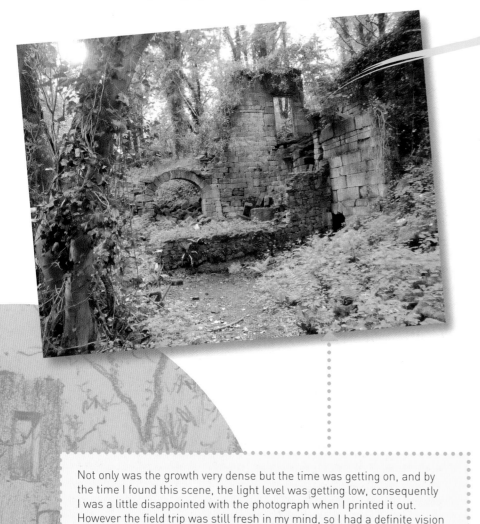

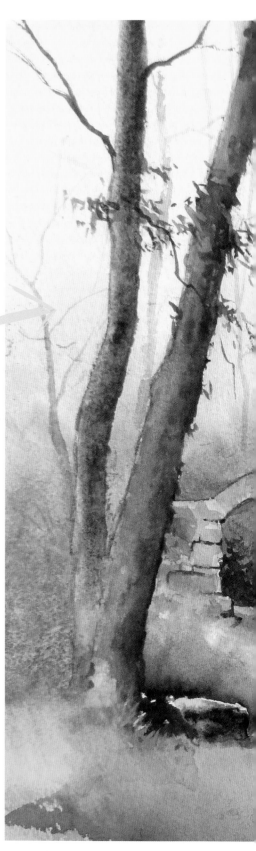

Not only was the growth very dense but the time was getting on, and by the time I found this scene, the light level was getting low, consequently I was a little disappointed with the photograph when I printed it out. However the field trip was still fresh in my mind, so I had a definite vision of the finished painting and sufficient information to work with.

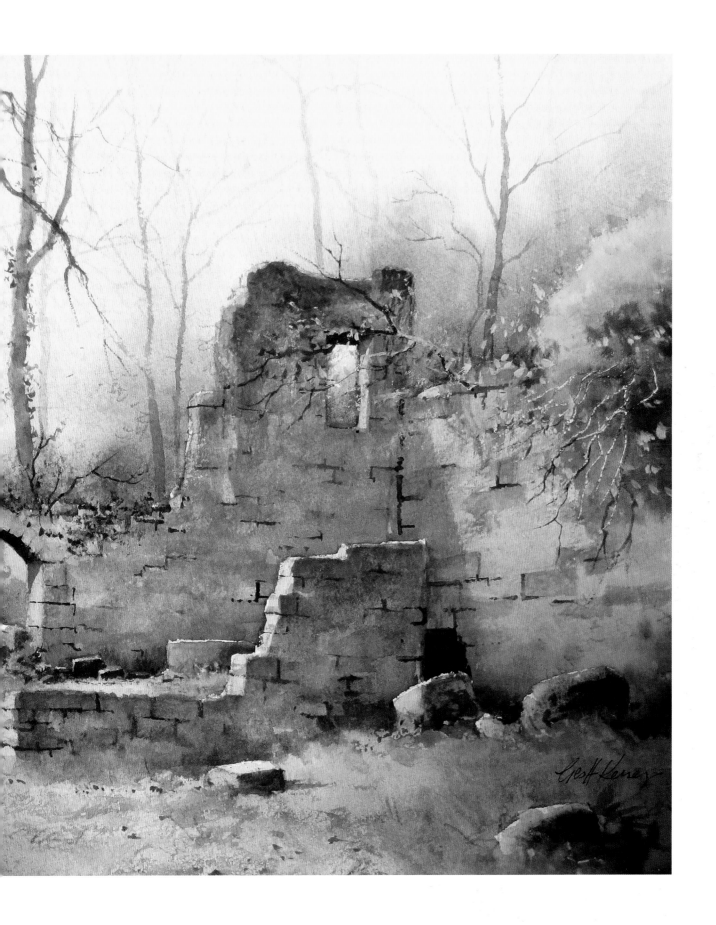

Often, with a subject like this, you need to try and see through the clutter to the essentials of the scene, aiming to simplify it, taking from it the elements you like, and editing the stuff that's getting in the way. A simple pencil sketch is a great help because it increases your familiarity with the subject, and helps you to find a way to achieve your goal. Here is a simple, fifteen-minute thumbnail sketch that gives me a feel for the subject and acts as a halfway stage between photograph and painting.

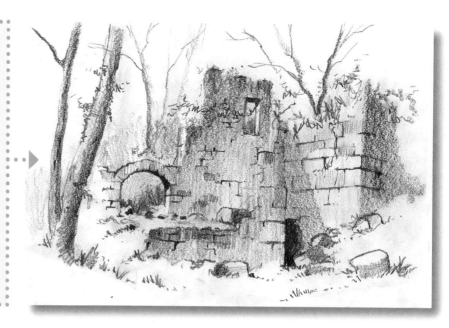

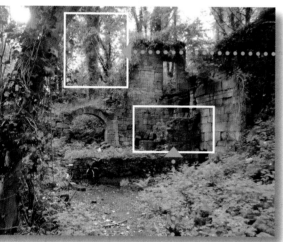

If you compare the photograph with the finished painting (opposite), you can see that the change is quite dramatic. I have opened up the background to make it lighter and have suggested some distant trees using thin grey washes, gradually strengthening the washes and widening the tree trunks to suggest some are nearer than others (see right).

I used a cool green-grey and a warmer purple-grey to suggest the wooded area behind the building and echoed this colour in the shadows on the stonework. In the photograph you can see that the stonework is mainly a cool grey colour, whereas I have painted it with a warmer, peachy colour (see right) to give it a glow, and pick it out from the background. I don't dislike the scene as it is in the photograph, with more verdant foliage and cooler stonework (therein lies another painting); it is just that I was inspired on the day to treat it in this way.

Sky and stonework background colour
Naples yellow and rose madder

Other changes I have made include bringing the trees at the far left more into the scene, where they serve to frame the building and give me an L-shaped composition.

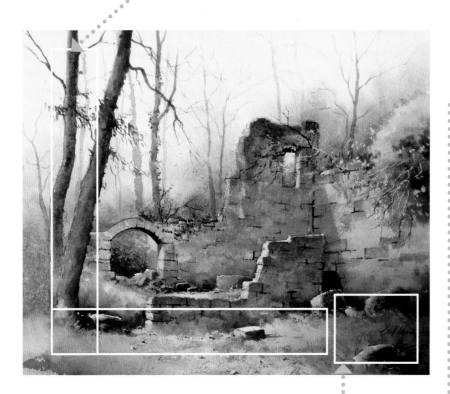

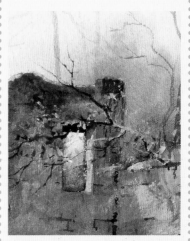

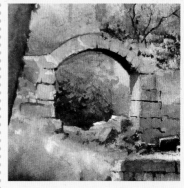

I cut out a lot of the weeds and ground-covering plants in the right-hand foreground, preferring to leave this as a quiet, partly unresolved area. I am often asked by students for advice on how to tackle foregrounds, which they find tricky. I understand the difficulty, because the temptation is always to overwork foregrounds, almost painting every leaf and blade of grass. I prefer to leave it loose, and in keeping with the rest of the painting, believing that you should try to leave something to the viewer's imagination. This also applies to detail in the walls, where you can see that I have refrained from including every little crack and crevice, preferring to suggest this detail with a few fine strokes of dark colour here and there. It is always better to add these details after the shadow colour has been applied, as unless you are very lucky, you will smudge them with the shadow wash.

On viewing the finished painting, I was particularly pleased with the glimpses of background seen through the low arch on the left, and the opening that was once a window on the right. The best way to achieve this is to mask the outer shapes at the outset, then when you paint the background, paint it right through these two spaces. This is preferable to adding the view through the gaps when you paint the stonework later, as that would lose the continuity of the distance. See A view through an opening, page 11.

Wall colours

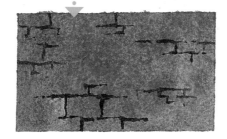

Stonework background colour (see opposite) with a glaze of shadow colour: cerulean blue and cobalt violet with a touch of viridian. Suggestions of cracks and crevices were put in with a brown made from cobalt blue and burnt sienna.

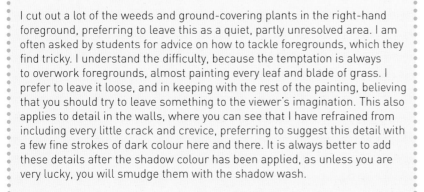

Rowing Boats

Where the River Derwent runs through the small Derbyshire town of Matlock Bath, its twists and turns through the wooded banks provide the artist with plenty of good material. At the section of the river shown here on a bright November morning, the pleasure boats hired by the tourists to ply the waters during the summer months are moored briefly before being stored away for the winter. It was this high viewpoint and juxtaposition of bright blue painted vessels, framed by the rich overhanging autumn foliage, that attracted me immediately to the scene.

So far we have looked at how to make changes to the subject material in a photograph. I have explained how I can sometimes make the most of a poor photograph, or use the best aspects of one or two photographs to make a good scene. Every so often, however, when I am out with the camera, I find a perfect composition at the right time of year and the right time of day, which is just as exciting when I have printed it out back in the studio. Here is just such a scene.

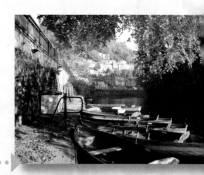

I took photographs in both landscape and portrait formats, but chose the latter as this format focuses our attention on the interesting collection of shapes, without us being distracted by more detail on the left and partly obscured river bank on the right.

If you look at the finished painting opposite, you can see that I have remained more or less true to the photograph. I did remove the furthest boat, as I wanted that clear expanse of water in the middle. There is a tarpaulin-covered structure on the jetty which I removed, but I left in the grit bin, as it served to break up the otherwise straight line. In the bottom right-hand corner of the photograph, the colour is very dark, almost black; you can see that in the finished painting I have lightened this, showing more blue and the reflections of the trees.

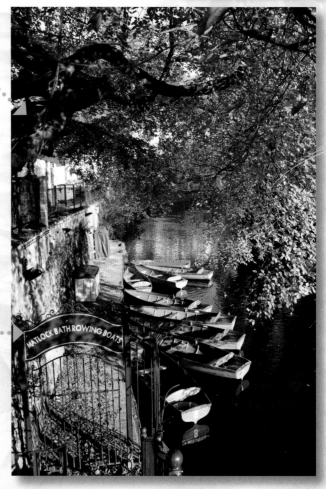

MATLOCK BATH ROWING BOATS

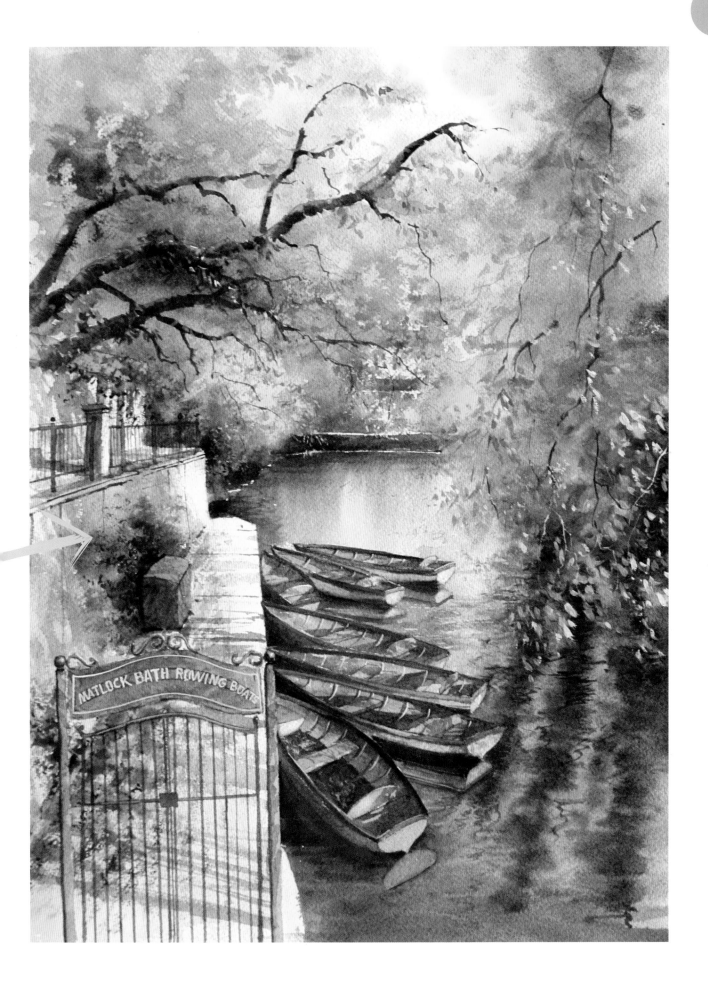

Keen as I was to get on with the painting, I knew it was very important to get the drawing right first. I decided not to do a sketch but to go straight onto the watercolour paper, drawing it out in outline only, so that it was ready to paint over. It took a while to get the shapes of the boats to look believable, and I had to do quite a bit of rubbing out and redrawing before I felt I had got the shapes and perspective just right. It is vital to get this line drawing stage correct, as no amount of skill with the paintbrush will salvage the painting if the underlying draughtsmanship is flawed. The boats are demanding to draw because we are looking down into this scene, and we see their interiors, with the rib-like construction, varnished wooden seats, back rests and top edges.

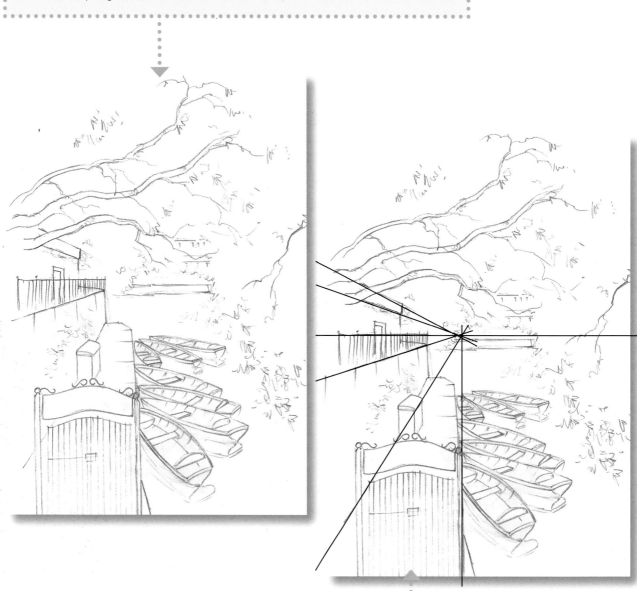

It was also vital to establish the converging perspective lines along the jetty, wall and upper path that lead us into the scene and establish the eye level line. These lines converge at a vanishing point on the eye level line, and because we are looking down on the scene, the boats and river are below the eye level line.

Colour mixes

The other element of the scene I particularly liked was the domination of two colours: the blue of the water and boats and the oranges and yellows of the overhanging foliage. Since these are complementary colours (opposites on the colour wheel), when you get them side by side, it gives your painting added impact. For this reason, I don't think this scene would have worked as well in the summer.

Cobalt blue and French ultramarine for the river.

As above but with a touch of burnt sienna to darken it for tree reflections.

Cobalt blue and cerulean blue for the boat hulls.

Raw sienna and burnt sienna for the varnished woodwork of the boats.

Dark brown mixed from burnt sienna and cobalt blue, also used for the boats' woodwork.

Indian yellow, burnt sienna and lemon yellow with white gouache, for the opaque leaf shapes.

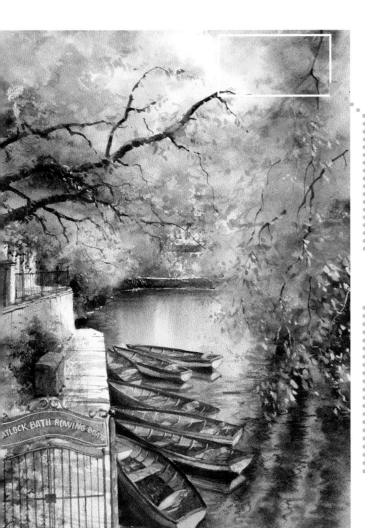

I kept the foliage at the top of the scene soft by brushing it all in wet into wet; this contrasts well with the harder, more defined shapes of the boats.

In the bottom right-hand third, I used sharper, more definite brush strokes with opaque paint to pick out the brightly coloured leaves against the dark blue background.

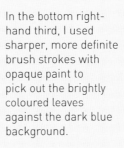

Vernazza, Italy

Cinque Terre (or 'five lands') is a rugged portion of coast on the Italian Riviera, so called because it is made up of five villages, Monterosso al Mare, Vernazza, Corniglia, Manarola, and Riomaggiore.

I have to confess that this is one of the very rare occasions when I have created a painting from a photograph that was taken by someone else, and in fact I haven't been to Cinque Terre, although I have definitely put it on my list of places to visit. I was asked to produce some online tutorials for an art instruction website, and they sent me the photograph of Vernazza and asked me to paint it as a watercolour lesson. I was instantly inspired by the quality of the photography, the beautiful colours and the almost perfect setting.

One problem I had with the photograph was that it was almost too good! Every little detail was picked out in sharp focus. This was very useful in that it gave me stacks of information, but I felt I needed to do a bit of interpretation: softening the colours slightly, choosing more pastel shades, and going for a more painterly effect, rather than getting bogged down with too much detail, which can result in a very accurate rendition that is somehow lacking freshness and spontaneity.

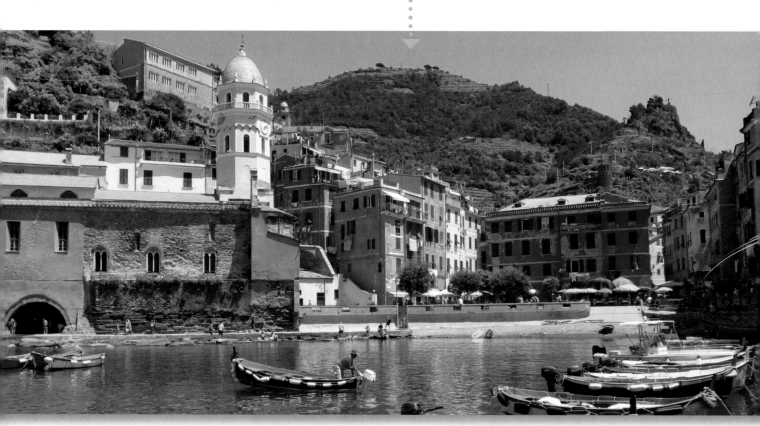

Photograph by Hannah Brownlow, reproduced by permission of Paintbox Media.

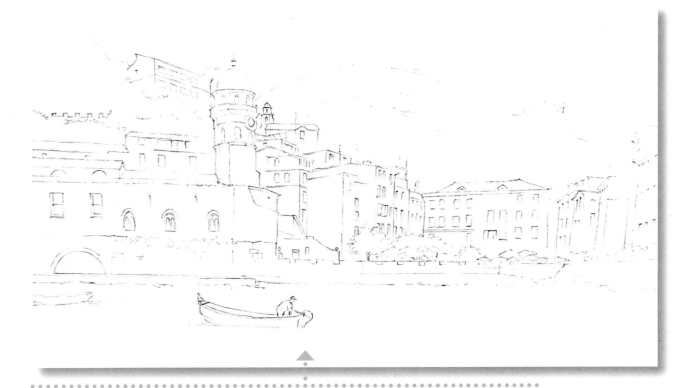

Before I could put brush to paper however, I had to spend some time carefully drawing out the subject onto a full imperial (76.2 x 55.8cm/30 x 22in) sheet of NOT surface watercolour paper. If you look at the drawing, you can see the shapes and positioning of the buildings, as in the photograph, but with a bit of simplification. I thought the boats in the bottom right made it a bit too busy, so I left them out. I didn't leave out any buildings, however, as it is possible to oversimplify a scene and lose the essential elements that make it the place it is. Another problem with oversimplification is that the scene can attract the viewer from a distance but be disappointing on closer inspection. I aim to make paintings atmospheric enough to attract the viewer but with enough detail to be interesting close up.

The finished painting.

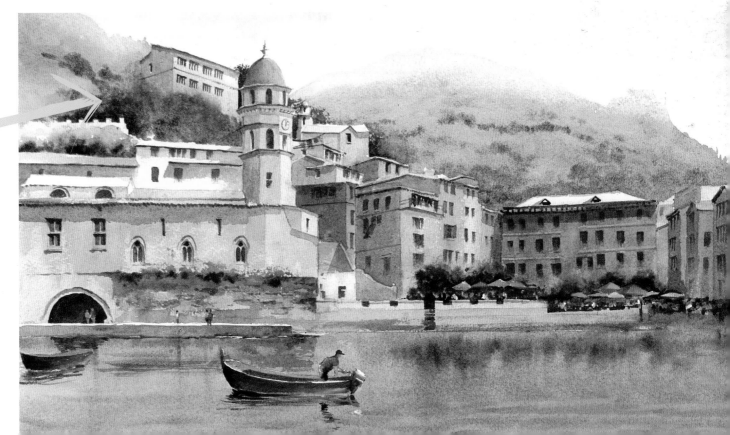

Before commencing the painting, I masked out the top edge of all the buildings right across the scene, before also masking out the boats on the water and the parasols in front of the hotel. This ensures that you don't lose the definition on these important shapes, and you still have clean white paper to lay the bright washes on, when you are ready.

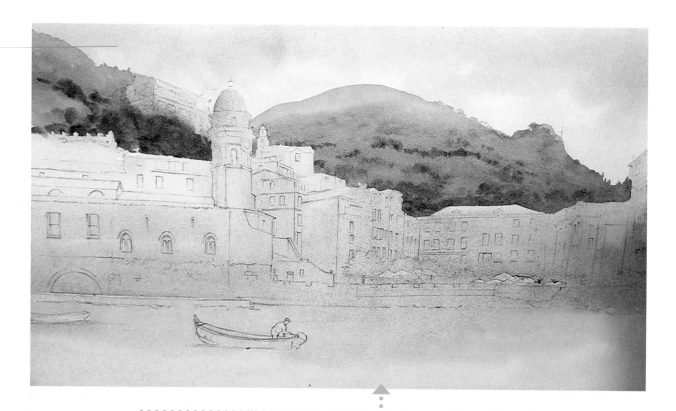

After brushing in a pale wet-into-wet sky, I painted in the background hills using various mixtures of cool greens and blues. I avoided putting too much detail of farming activity and scattered dwellings on these background slopes, because I wanted this part of the scene to be distinctly cooler in colour and simpler in execution compared to the warmer colours and slightly more detailed rendering of the buildings in the middle distance. In a subject such as this, it is a mistake to treat every building as a single entity, painting them one at a time and mixing a separate colour for each one. Instead, once I had removed the masking fluid from the top of the buildings, I put in a unifying, all-over, wet-into-wet wash with various warm, light mixes of yellow, orange and purple (see Colour mixes, opposite). You may think this is a strange approach, because if we look at the photograph (see detail, below), the buildings are definitely separate blocks, in separate colours; but giving them that all-over wash at the outset brings a harmony and consistency to the scene.

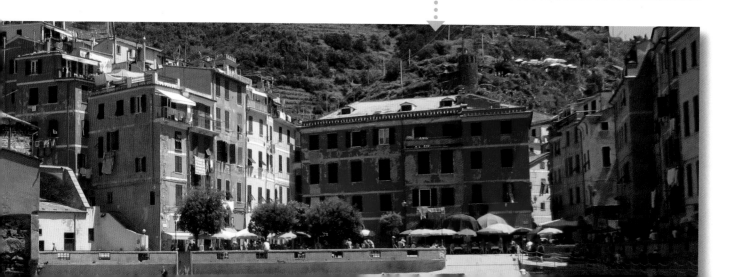

As I worked on the whole middle distance area, I gradually formed the shapes of the different buildings by careful use of shadow, observing detail and deciding what to include and what to omit. The finished painting does not include every architectural detail and bit of clutter from the photograph, and details like windows and shutters are simplified into one or two quick brush strokes. For this purpose I have a few small flat brushes in different widths, that with one stroke can create a rectangular or square shape, avoiding rounded edges (see Using flat brushes on page 12).

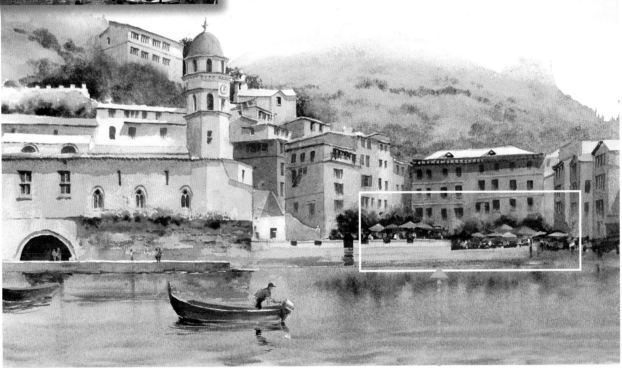

Colour mixes

The first five bright, warm colour mixes were used for the unifying wash over the buildings:

 Aureolin and burnt sienna

 Rose madder

 Burnt sienna and rose madder

 Cobalt blue and rose madder

 Naples yellow and rose madder

 Sea mix
Cobalt blue and viridian

I particularly liked the bright primary colours of the parasols, contrasted with the dark green of the shaded foliage behind them, and the quick dashes of opaque colour that hint at people and general activity.

Lake Shore

An excellent way to spend a day in the Lake District is to catch the ferry from Glenridding to Howtown on Ullswater, before returning to Glenridding on foot using the well-trodden footpath. This varied walk follows the lake shore for much of the way, but also passes through ancient woodland, over fern-covered hillsides and rocky outcrops and along farm tracks. It is a goldmine of material for the landscape artist.
I found this scene by looking over a dry-stone wall as we ascended the path from where the boat had dropped us off fifteen minutes earlier. This gave me an excellent view of the flat pastures, clusters of trees, scattered farm buildings, and the edge of the lake; all nestling beneath the steep backdrop of hills.

I particularly liked the way the steep slope of the hills gradually levelled out to the floor of the valley, and I wanted to make these hills the backdrop to the whole scene, without even a glimpse of sky. This is exactly what I got in the top photograph; but I wanted to include more of the buildings in the foreground, and from this angle they were not very visible, so I walked on a few more metres and took the bottom photograph, where not only did I get a better view of the buildings but could see a bit more of the lake. The hill didn't look quite so impressive from this angle and some of the little clusters of buildings in the valley bottom were obscured, but this didn't matter as I could get that reference from the first photograph. You may think that using two photographs to make one scene in this way is a bit contrived, and that it is cheating to paint a view that you can't exactly see by standing in one place. In my view, moving a few objects to help with the design and composition is acceptable artistic license, so long as it doesn't fundamentally change the sense of place and the atmosphere of the scene.

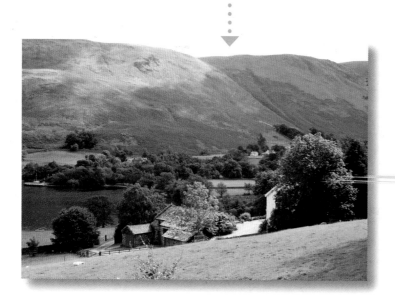

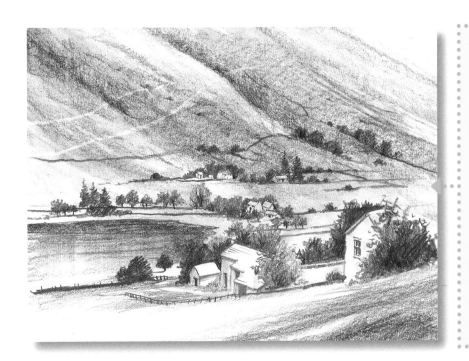

I did this pencil sketch to help me further understand the scene and to establish tonal values and composition. I was able to use the variety of grey tones afforded by the graphite to describe the curves and undulations in the hills. A sketch using just graphite pencils is a good discipline as it makes you explore the full range of tonal values in your photograph. This is because without colour to define different areas and objects, tone is all you have. I have heard it said that a good painting should still work when photographed in just black and white.

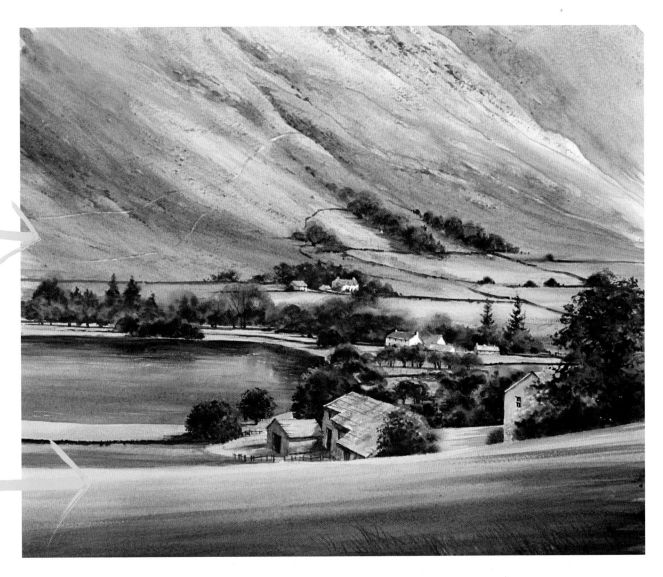

When I started to paint the finished work, shown opposite, I decided that I wanted to play down the green a bit. This may seem strange as it was August and we are basically looking at grass and trees; but in my experience, too much green in a painting without anything to break it up can look a bit flat. I decided to introduce some violet (see the colour chart below), particularly in the background hills.

Colour mixes

Greens for hills and fields

Bright green mixed from aureolin and cobalt blue with a touch of raw sienna.

A darker green mixed from aureolin and more cobalt blue with a touch of burnt sienna.

Dark green mixed from viridian, French ultramarine and burnt sienna.

Colours used to break up the greens

Violet mixed from cobalt blue and cobalt violet.

Cobalt blue, cobalt violet and light red.

In the background hills area, I made good use of the rough texture of the paper to indicate a few areas of scree by taking advantage of the 'hit and miss' effect one gets by quickly dragging a dry brush over the surface.

The flecks created by the dry brush technique were then enhanced with a touch of shadow, suggesting scree or rocks and stones on the hillside.

I was particularly pleased with the indication of a path that is lighter than the background, which I achieved by painting a thin line with a fine brush and water and dabbing it with a tissue immediately to remove the top surface of paint.

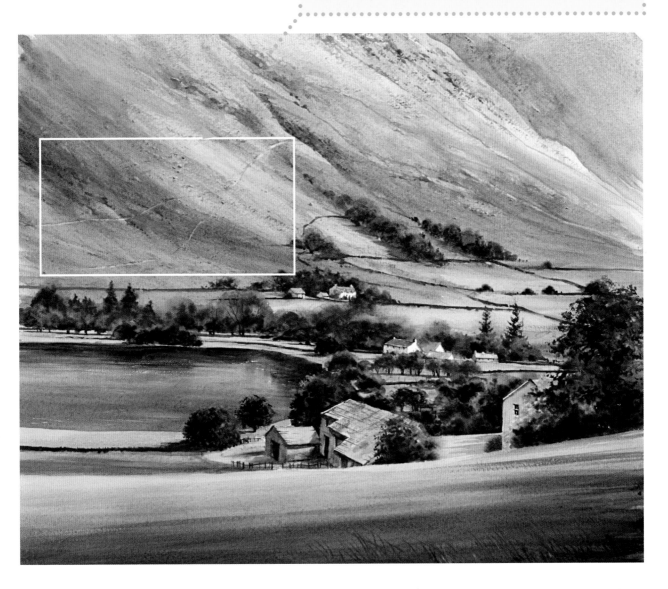

Canal

It was early October when I took this photograph on a walk alongside the Cromford Canal, near Matlock Bath in Derbyshire, UK. The autumn colours must have been a little late in arriving, as there is just a hint of orange and yellow amid plenty of green. This was a big part of the attraction of this scene for me; I liked the contrast between the glimpses of warm autumn colours around the top and middle of the scene and the cool blue and grey shades of green that surround them, and also the hint of muted pink provided by the wild flowers on the right-hand bank.

I write a lot in this book about colours being warm or cool, because considering colour temperature in this way is a good habit to develop, and using colours of contrasting temperature can really give your paintings a lift.

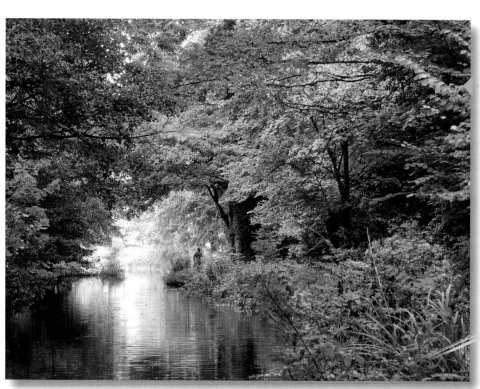

Because I felt that this scene was more about colour than tone, I didn't do a tonal value pencil sketch this time, preferring instead to explore the range of colours by doing a small water-soluble coloured pencil sketch. It is sometimes fun to experiment with different media in this way.

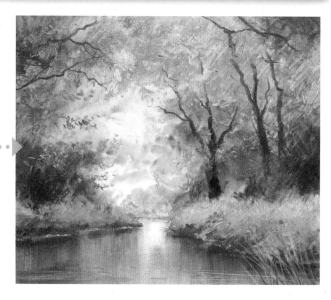

The finished painting (below) is quite loosely painted, and is more about light, colour and atmosphere than detail. With this in mind, I did not want to focus too much on the details of foliage and vegetation, thus painting it too tightly. I kept the initial drawing (right) very simple, just indicating the basic areas of foliage, and establishing the composition with a few basic lines. I wanted to make the bright light where the canal rounds the bend and disappears out of view the focal point, and I positioned this, not in the centre, but approximately a third of the way in from the left and a third of the way up from the bottom. It is good to bear in mind this simple rule of thirds (see Composing from photographs, page 13) when composing a painting, and in fact you can see that I was mindful of this when taking the photograph itself, planning the composition, as I often do, as I looked in the viewfinder. Whenever I take photographs, with the exception of family snapshots, I am looking at the scene as a potential painting in this way.

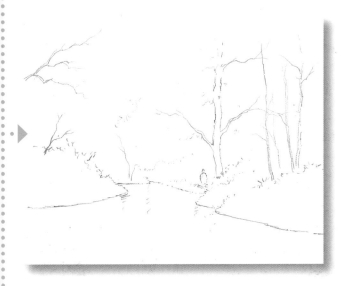

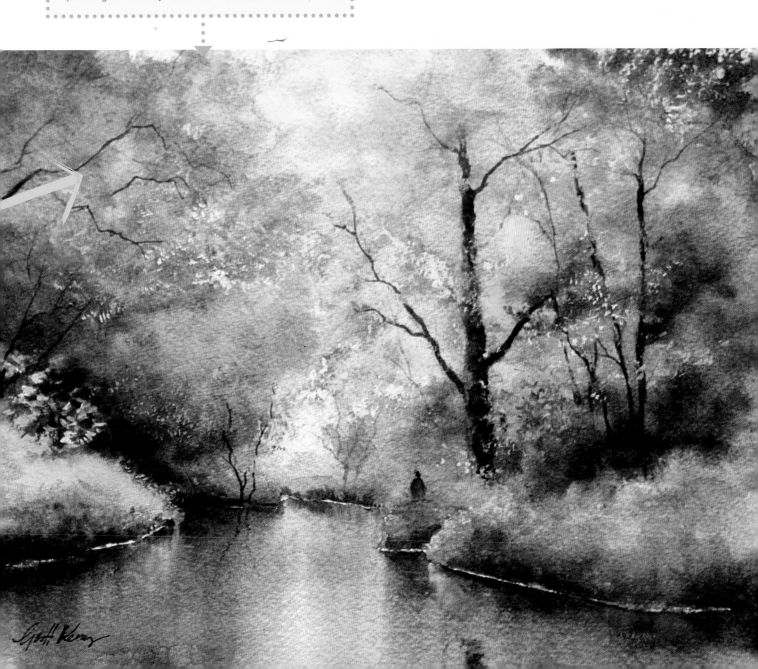

I picked out the tops of the canal banks by applying masking fluid onto a wet background (see page 11). I pre-mixed a range of colours (see below). These were applied to a wet background, creating soft edges. When the masking fluid was removed from the top edges of the banks, it left white-paper highlights in soft shapes which looked more like foliage than if the masking fluid had been placed on a dry background. I could then just tint these areas with a light colour, to appear as brightly lit foliage with darker foliage behind it.

When these initial washes had dried, I applied some dry brush work to represent the foliage and define it a bit more, with the same washes as the background. I introduced a few touches of opaque colour, dry brushed here and there, to suggest brightly lit leaves. These colours were created by mixing white gouache with various colours. In addition to the dry brush work, I added a few leaf shapes with a fine pointed brush. These marks are most effective in areas where there is a dark tone behind them, thus maximising the light against dark effect. The same brush was used to pick out a few fine branches.

Colour mixes

A cool grey-green mixed from viridian and cobalt violet. To make it greener, add more viridian; to make it greyer, add more violet.

A muted pink-violet mixed from cobalt violet and Naples yellow. This is useful for glimpses of wild flowers and blossom.

A redder version of autumn gold mixed from aureolin and rose madder.

A cool blue-green mixed from viridian and cerulean blue.

A rich, autumn gold mixed from aureolin and burnt sienna.

A muted autumn green mixed from aureolin and cobalt blue with a hint of raw sienna.

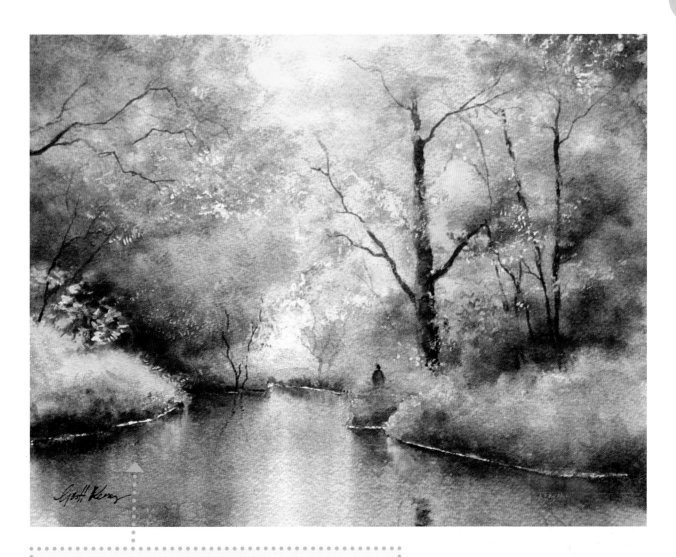

I mixed more of the same colours for the reflections in the water, softening these into the wet background with downward vertical brush strokes.

It may interest the reader to know that a few weeks later I used the same reference photograph again to paint the scene in oil.

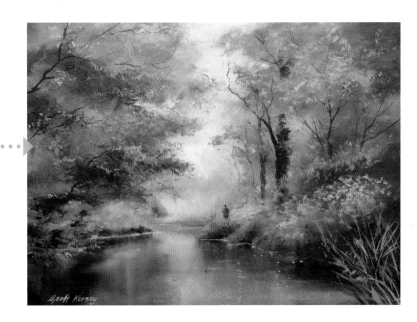

Winter Park

I have lost count of the amount of times I have painted Chatsworth House, the ancestral home of the Duke of Devonshire. With its surrounding grounds and park, it makes an excellent subject, which fortunately for me is popular with painting buyers, many of whom have visited it. It is also very popular with watercolour painting students, who have either seen my paintings of it or been there themselves and would like to tackle it as a landscape subject at one of my workshops.

Initially I was reluctant to use it as a subject for a workshop, considering it too complex to complete within a day; but after repeated requests, I decided to give it a go, and chose to depict it in its winter cloak, as this would reduce the number of colours and enable us to simplify the surrounding landscape.

You can see that I have deliberately added a touch more colour into the distant hills, as I felt they appeared a bit dull and grey in the photograph. These hills were brushed in while the sky was still wet so as to get a soft, misty, distant effect. To achieve this, it is important to mix the colour for the background hills before you start painting the sky, otherwise while you are mixing this hill colour, your sky will be drying, and the opportunity for painting wet into wet will be gone.

Walking towards the house, following the river Derwent from the car park at the southern end of the park, affords some splendid, inspirational views, and it is from this path that I took the photograph one cold January day.

You can see a few obvious changes between the photograph and the painting (opposite). I cropped the scene on the left and slightly altered the position of the house by moving it to the left, which placed the focal point in the top third of the composition. You might wonder why I didn't just stand in a slightly different position and get the exact view I wanted, but the problem is that this way, the trees obscure the view of house. I left out some of the tree detail on the left-hand side of the foreground bank to provide a more open view of the river, and I deleted altogether the right-hand tree, as not only did it obscure the view, but it made the composition too symmetrical, losing that very useful 'L' shape (see Composing from photographs, page 13).

While the house doesn't occupy a great deal of space within the scene, it is the focal point, and is such a well-known subject that it was very important to get it right and make it look convincing, so I also took a photograph using the telephoto lens, so that I would have more detail.

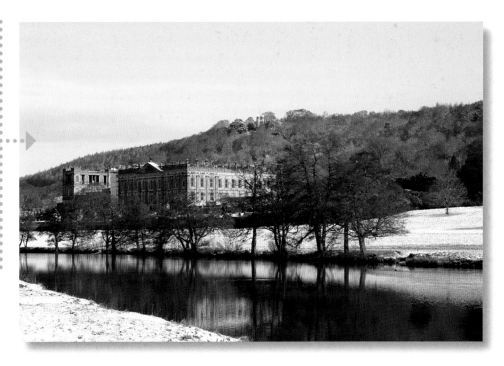

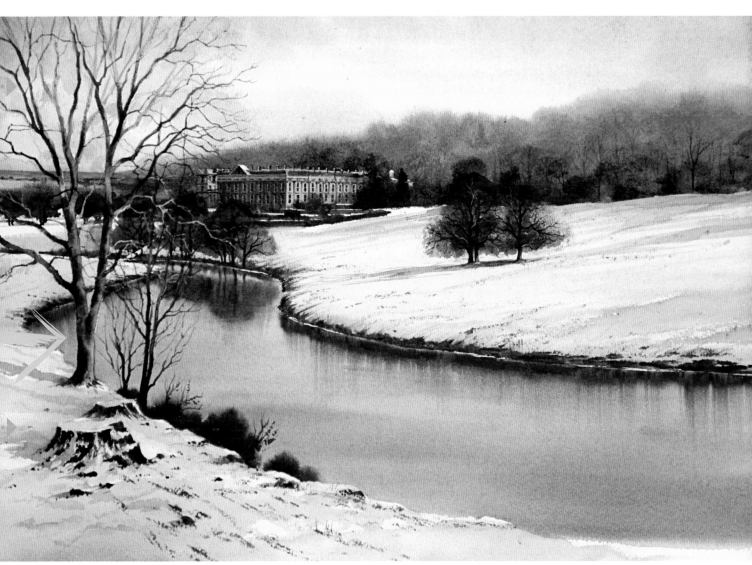

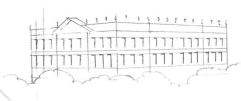

Painting a grand stately home like this is a more disciplined and exacting task than a country cottage or rustic farmstead; but there is a way to tackle it which simplifies it and makes what at first seems daunting, achievable. The best approach is to ignore the architectural details and complexities at first, trying instead to break the structure down to its basic shape. Most buildings are basically boxes or sets of boxes when viewed in this way. You can see how I applied this method to this subject below.

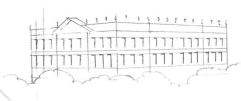

I did the drawing with a 0.5 HB mechanical pencil to give me fine, accurate lines. It is much easier to make corrections and redraw at this stage than to try and remove marks made with paint later. I started by treating the house as a basic box shape. It is important to note that from this angle, the front (dimension A) appears shorter than the side (dimension B). Careful observation is vital so that you draw what you actually see, not what you think you see.

It was important to establish the centre of the house front. This would be the exact middle if we were looking at it straight on, but from this angle, use this method to calculate the position of the centre. Draw two diagonals from corner to corner, and where they cross, draw a perpendicular line. This is the centre and the position for the top of the pitched roof. I have divided the side of the house in the same way, to help with the positioning of the windows. Space them from the middle outwards; don't start at one side and work along.

Here I have drawn horizontal lines through both sides, to line up the windows exactly. This may seem laborious, but if any of the windows were out of line, it would look haphazard; fine for an old cottage, but not for a subject like this. The final part of the drawing was to soften the base of the house, which is partly obscured by trees and bushes, disguising the box shape and settling the structure in the landscape.

Colour mixes

You can see from the colour swatches that I stuck to a limited palette. This gives the painting a consistency and harmony.

 + =

Naples yellow and vermillion; a warm glow for the lower sky, also included in the background hills and reflections in the river.

Cobalt blue and a bit more rose madder for a warmer, more purple blue. Used in the background hills, reflections and shadows, particularly on the house.

When the colour to the left is brushed into the colour on the far left, it creates a pleasing grey, useful for the background hills and the sky.

Cobalt blue and a touch of rose madder, used in the sky, river and shadows.

Raw sienna and burnt sienna; the base colour for the house; also added to the background hills.

Burnt sienna and French ultramarine, used for various browns throughout the painting.

I varied the colour of the branches on the large tree between dark brown, a lighter brown and an opaque beige colour made from Naples yellow with a touch of raw sienna. This gives the tree a more three-dimensional look than if the branches were all one tone and colour.

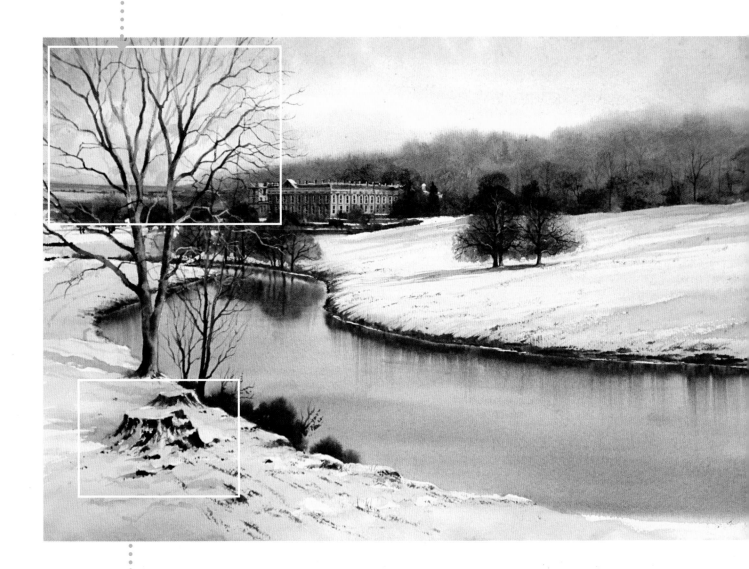

I particularly liked the snow-capped tree stumps, as I felt they provided some foreground interest.

On the same visit, I took a portrait format photograph of the same scene (below) and soon after I had completed the first painting, I painted it again in this format, which is more unusual for a landscape. I can't really decide which I prefer, as I think both compositions work.

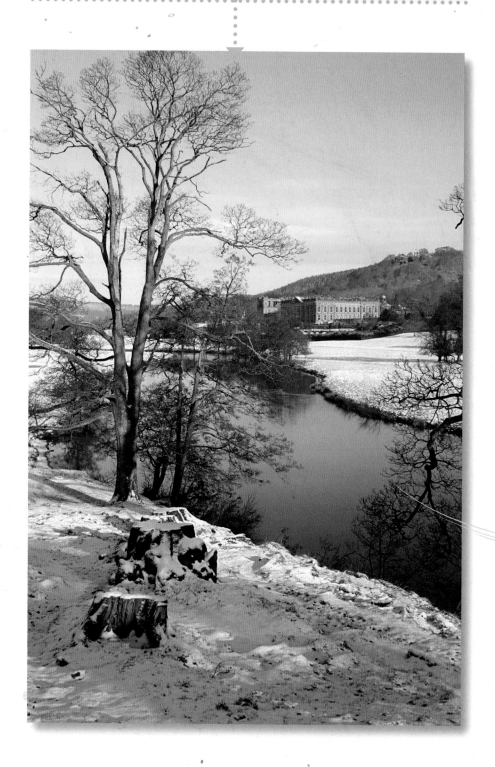

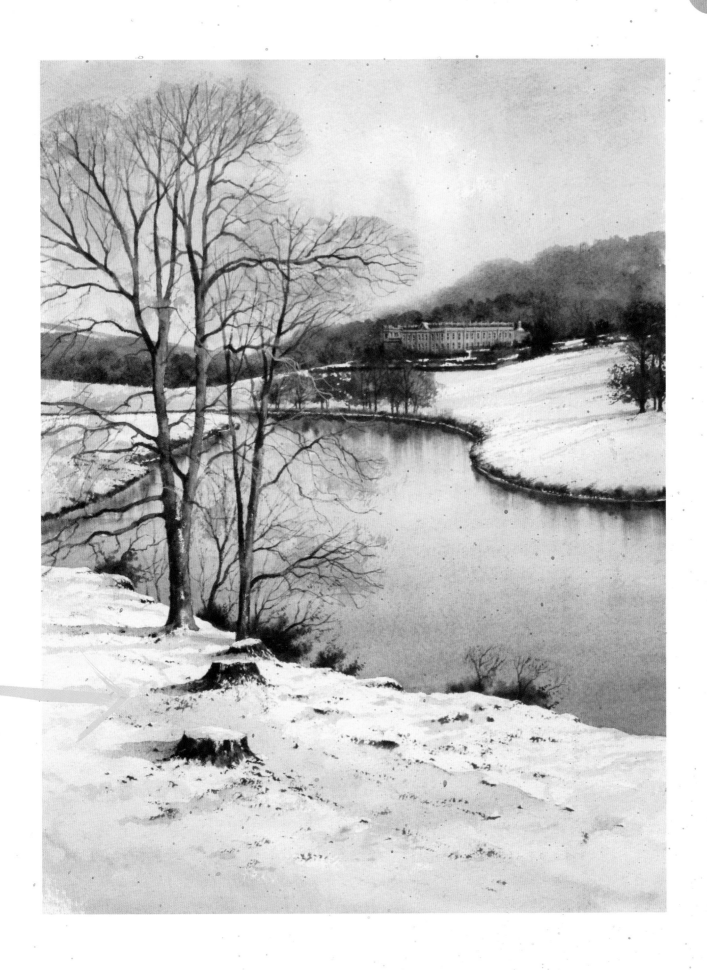

Country Lane in Autumn

I was commissioned recently by a client who lives just off this lane, to produce a painting of it to mark a 'significant birthday'. I don't seek out commissions, preferring to choose the subjects that mean something to me personally and give me the inspiration to paint them. But I was lucky on this occasion, as the clients live not far from me, and I know this lane well, having walked it many times, and painted other stretches of it once or twice in previous years.

I was approached to do the painting in October, but suggested that we wait until early November, when I knew the autumn colours would be at their best. Unfortunately, by the time I visited the scene with my camera, a lot of the leaves had already fallen. However the advantage of this was that I could get a better view of the shapes and structures of the trees, and more light was getting through to illuminate the road and verges. With a bit of imagination I was sure I could put some autumn colour back into it.

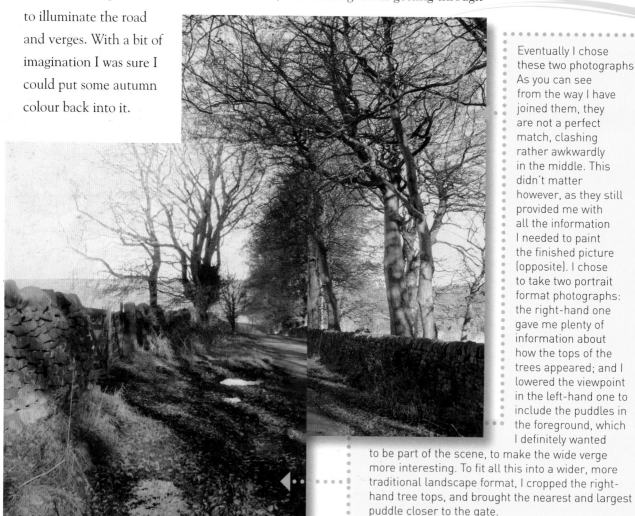

Eventually I chose these two photographs. As you can see from the way I have joined them, they are not a perfect match, clashing rather awkwardly in the middle. This didn't matter however, as they still provided me with all the information I needed to paint the finished picture (opposite). I chose to take two portrait format photographs: the right-hand one gave me plenty of information about how the tops of the trees appeared; and I lowered the viewpoint in the left-hand one to include the puddles in the foreground, which I definitely wanted to be part of the scene, to make the wide verge more interesting. To fit all this into a wider, more traditional landscape format, I cropped the right-hand tree tops, and brought the nearest and largest puddle closer to the gate.

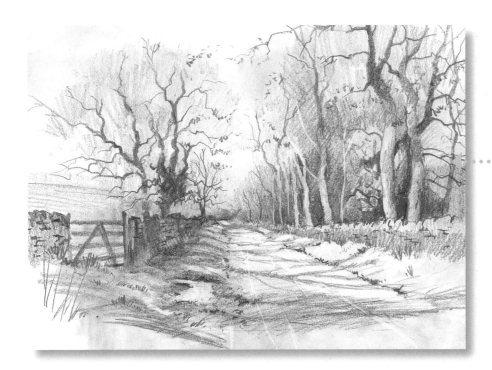

Before committing anything to the watercolour paper, I did this pencil sketch. The main purpose of this was to establish the track and perspective of the road, including the tiny distant bit which was not clear from the photograph. I also wanted to get a general feel for the composition and the shapes and structure of the trees.

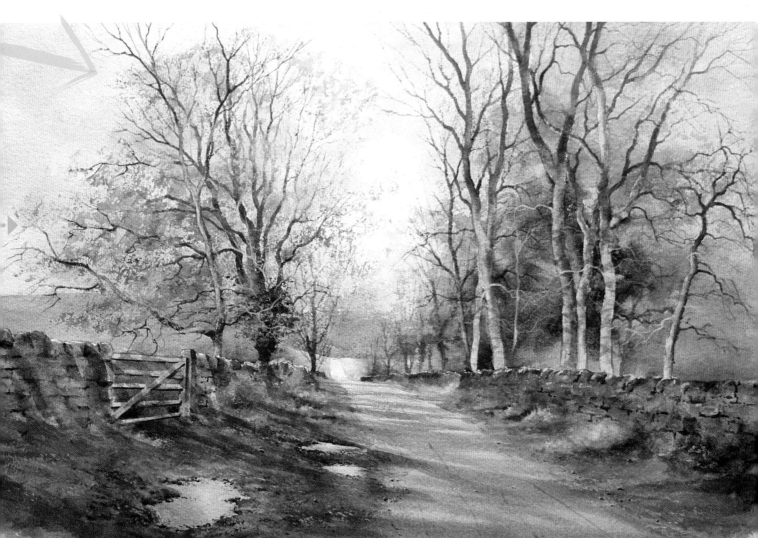

I particularly liked the light against dark of the trees on the right-hand side of the road, and the way that, as your eye follows the trunks upwards, they change to dark against light when silhouetted against the sky (see right). In order to achieve this, as soon as I had drawn the subject on watercolour paper, I masked the main tree trunks. If you look at the stage shown above, you can see that I also masked the tops of the dry-stone walls, the gate and the foreground puddles. I chose not to mask the thinner tree branches that criss-cross the trunks and foliage, as it is difficult to render the fine, delicate lines required for these with masking fluid. I preferred instead to put these in with a very fine brush using opaque mixtures of Naples yellow and lemon yellow (see right). To keep these colours sufficiently opaque, it is important not to dilute them; I use the paint as it comes straight out of the tube, with a slightly damp brush to encourage it to flow.

It was important to achieve the wet look of the puddles, shown in the photograph (above). When I removed the masking fluid from the puddles in the foreground, they looked like blotches of stark white paper (see the stage, left). This did not matter however, as I needed a white background in order to make them look wet. I approached this by aiming to paint light and reflection, not water as such. I wetted these areas of white paper, then brushed in light washes of sky blue, then autumn orange respectively. When these had dried, I suggested bits of stone and dead leaves around the edges of the puddles, along with the rest of the foreground.

During the first painting stage, shown opposite, after wetting the whole of the top two-thirds of the paper with clean water, I floated in a range of autumn colours. If you compare this with the photographs (right), you can see that I left out much of the grey mass of twigs and branches above the centre, preferring to use warmer, brighter, more autumnal colours, shown below. While I enjoy these reds, browns and yellows, I think they can be a bit too much if there is no relief, so I introduced the area of dark green you can see behind the right-hand cluster of trees. I then echoed this colour behind the gate on the left-hand side, both for the sake of balance, and to contrast with the light colour on the bars.

As you can see from the finished painting below, I stuck mainly to the same colour scheme I had used in the tree foliage and background, to render the dry-stone walls, verges and road. With a vivid colourful scene like this, a limited palette is particularly important as it glues the whole thing together and prevents it from becoming an uncoordinated riot of colour.

Colour mixes

 Indian yellow for autumn foliage.

 A cool grey mixed from cobalt violet and viridian.

 Cobalt blue, rose madder and a touch of burnt sienna for shadow.

 A rich, dark green mixed from viridian, French ultramarine and burnt sienna.

Indian yellow and aureolin for autumn foliage.

 Aureolin and cobalt blue for the verges and to paint among the foliage.

 Viridian and cerulean blue, a blue-green used sparingly on grass verges and in the wall.

Consider the dry-stone walls in the photographs and compare these to the ones in the finished painting. In the photographs you can see every stone and nook and cranny, whereas in the finished painting I have suggested a few stone shapes, interspersed with a few dark lines to suggest the gaps between them. Leaving it partly unresolved in this way allows the viewer to use a bit of imagination and become involved in the scene rather than just being an onlooker.

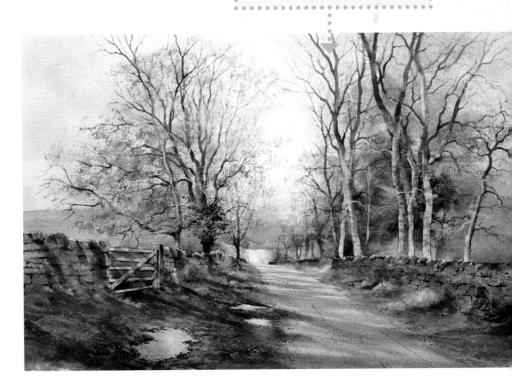

Mediterranean Street Café

For a recent programme of one-day watercolour painting workshops, I chose as a subject 'a Mediterranean café scene'. I often plan these themed painting days months in advance in order to be able to advertise them effectively, without having a specific location in mind, leaving that decision until much nearer the time. This often results in a search through my photograph files with just days to go, to find a suitable subject. It was on just such an occasion that I came across the photograph (right), taken on a holiday in Soller, Majorca. It occurred to me that while it had great potential for a painting, it was too ambitious for a one-day workshop, where I try to arrange the day so that most people go home with a finished (or almost finished) painting that they are pleased with.

I really like the entire scene that you see in the first photograph (above, right) and made a mental note to paint it in its entirety for myself at a future date. However, for the purposes of the workshop, I cropped it down to a smaller, simpler scene in a portrait format (right). Despite this being an edited version of the full photograph, and not my intention when I took the shot, I think the composition works really well, and is full of interesting detail and challenges. I love the way the plane tree opens out into a bright canopy, framing the lower, busier part of the scene, almost echoing the shapes of the parasols that are sheltering the diners from the midday sun.

It is not only when I need to simplify a scene for teaching purposes that I crop a photograph so drastically. Indeed I often get my photograph on the computer screen and, using the basic crop tool that is already installed on most computers, look for a part of the picture that will make a better, or just different, composition.

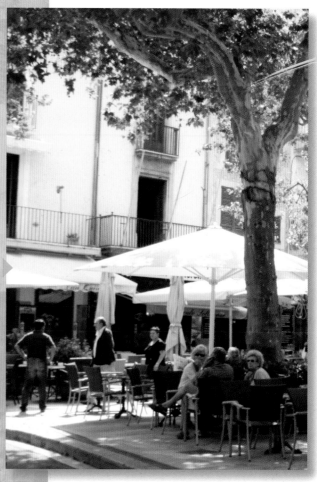

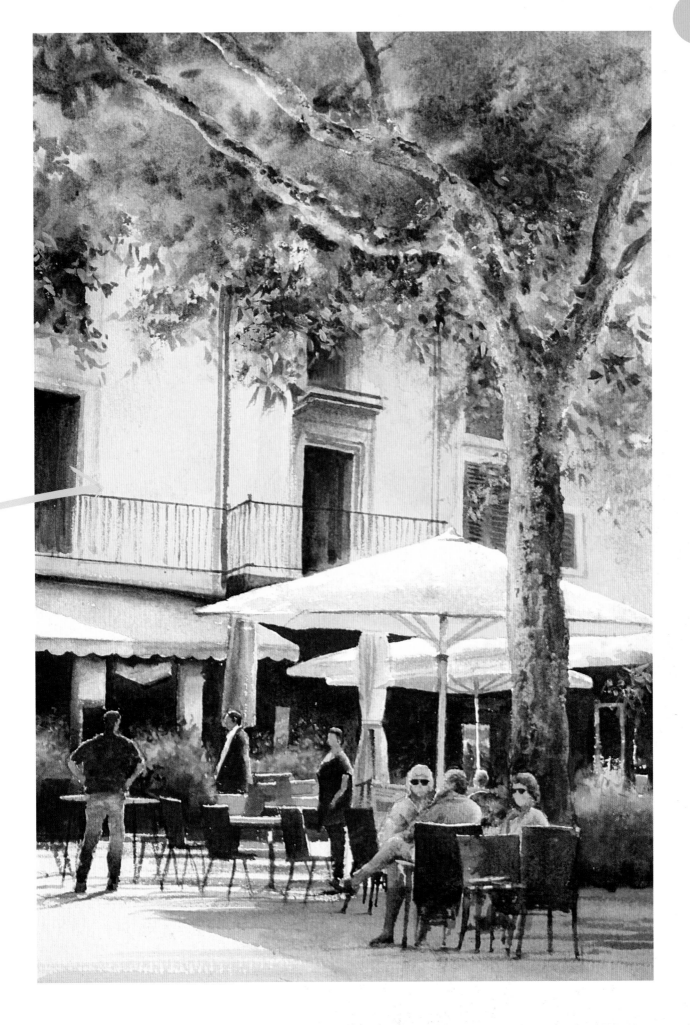

I made several changes and interpretations in the finished painting (opposite). The stucco wall in the background is almost white in the photograph, and I felt that this colour was too similar to that of the tops of the sunlit parasols and the large awning on the left. I differentiated between these by using a warmer colour on the wall (see Colour mixes below). This contrasted well with the parasols, which I left as pure white paper apart from the addition of a few shadows. I also felt that the dark behind the open doorways above street level, was too deep and too similar to the dark behind the main detail at street level, so I used a warmer red/brown colour (see below). There is quite a lot of detail and clutter in the dark, shaded area behind the people in the photograph. I simplified this area in the painting, merely suggesting detail like menu boards, posters and general furnishings.

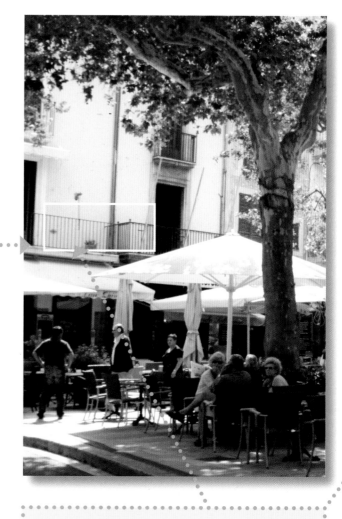

Whenever you are working from photographs, it is worth remembering that the eye of the camera is mechanical and, depending on the quality of the lens, records every detail in the scene. We, however can use our brains to interpret what we see and apply a bit of artistic interpretation. If you always bear this in mind, it will help you to create a painting that conveys something of your personality and how you feel about the scene, rather than just a slavish copy of the photograph.

The glimpse of railing on the balcony is only a small item in the scene, but does need to be rendered accurately with at least a straight line for the top and bottom. To ensure this looked convincing, I ran the brush along a ruler (see Straight lines with a brush and ruler, page 14).

Colour mixes

Naples yellow and light red for the walls of the building.

Aureolin, cobalt blue and raw sienna for the plane tree foliage and plants at street level.

Lemon yellow for the bright highlights in the tree foliage.

Viridian, French ultramarine and burnt sienna for the dark green in the tree foliage.

Raw sienna and burnt sienna for the doorways.

Burnt sienna, French ultramarine and rose madder for general darks.

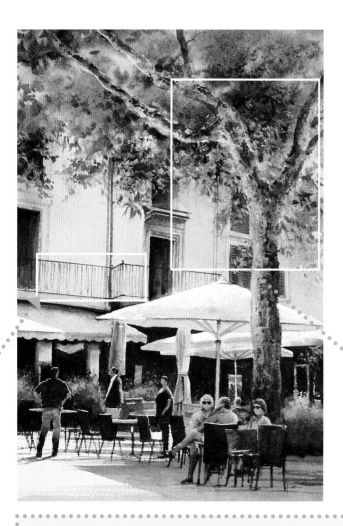

This close-up of the plane tree shows that the bark has a distinctive, blotchy pattern to it; this requires a different approach to most of the trees you might come across in the UK. I removed the masking fluid in stages, as described in Textured, blotchy bark, page 12.

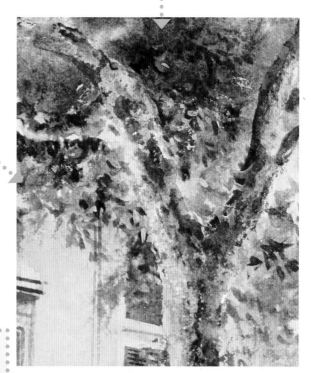

The trickiest part of this scene is the figures, but they are also a very important part of the subject, so it is vital to get them to look credible. In the photograph, you can see some of their facial features, so it is tempting to reach for a fine brush and start painting eyes, noses and mouths, scrutinising the photograph to get these details to look realistic. With respect to the reader, I suggest that you will find this very difficult. At best they may look over-detailed, at worst they can look clumsy and ugly.

I have a couple of approaches to this: firstly if the figure is sufficiently distant, like the woman in the centre, I don't even attempt facial features, but leave the face blank. If these people were a lot closer, this wouldn't work, but we can't clearly discern facial features at this distance, so it would be false to include them. Secondly, when the figures are a bit closer, like those seated in the foreground, sunglasses are a very useful device to help the viewer to read the shape as a face, and they are a lot easier to paint than eyes.

The most important aspect of including figures is to get the shape and proportion of the bodies and heads to look correct at the outset by drawing them carefully in pencil, before applying masking fluid to preserve them. This is mainly if they have plenty of colour behind them, as in this part of the scene. If the area behind the figures were less busy or much lighter in colour and tone, the masking out would not be necessary. When the background has been painted and dried, you can remove the masking fluid and begin to paint the figures themselves, as shown here.

Fishing Port

Staithes in Yorkshire was once one of the largest fishing ports on the north east coast of England, and it was an important source of minerals such as jet, iron, alum and potash. Today it is an attractive tourist destination, very popular with holiday makers and particularly with artists.

Whenever I go there, usually as part of a trip to several of my favourite locations along this coast, I take too many photographs; I suppose digital photography encourages this because it is so easy to print just the ones we want, and discard the rest. The downside of this is that you can snap away all day without taking too much care over what you are photographing. This was brought home to me recently when I heard a professional photographer's opinion that there is no such thing as a 'point and shoot' camera, just 'point and shoot' photographers. Recognising this fault in myself, I have recently started to take fewer photographs, but to consider more carefully those I do take, trying to make every one count.

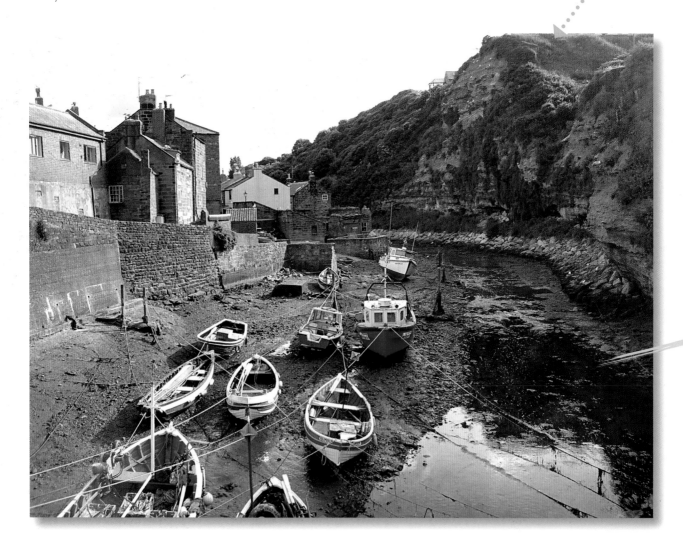

I chose this view looking up the beck from the raised elevation of a footbridge. I particularly liked the clutter of beached boats to the left of the water with the network of criss-crossed ropes. I find beached boats like this more interesting than floating ones, because of the juxtaposition of shapes and the varying angles at which they rest. In a scene that is full of natural earth colours, the hulls of the boats provide a welcome break with the splashes of blue, red and white.

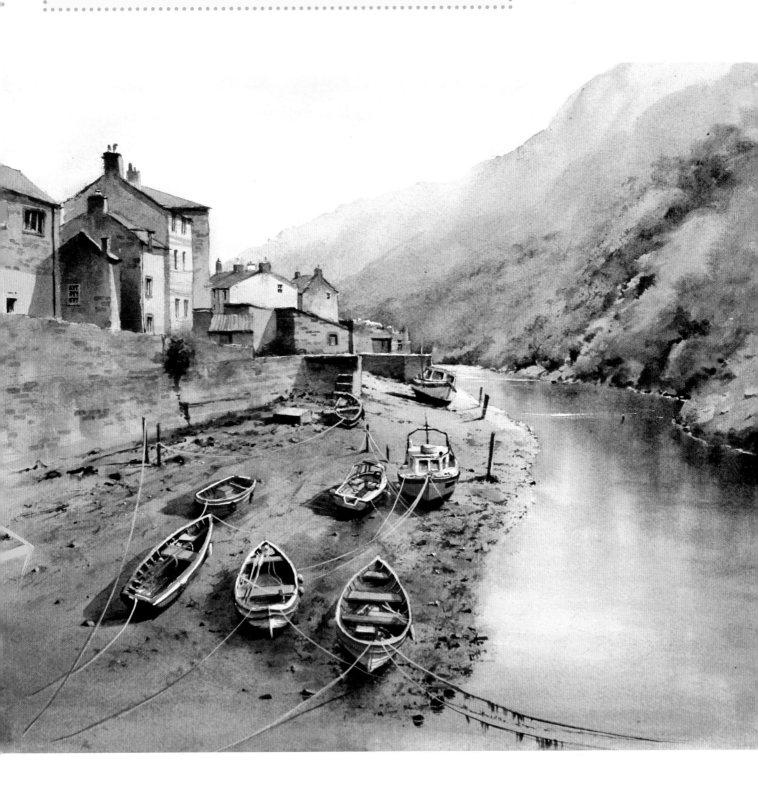

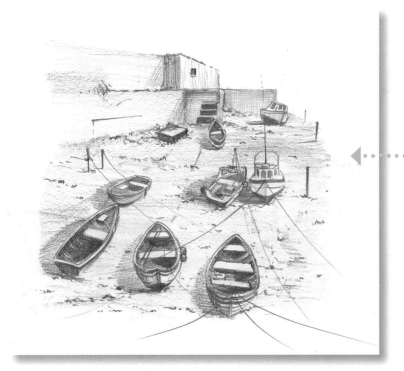

To get a feeling for the shapes and angles of these boats, I produced the pencil sketch shown here, deciding to leave out the two foreground ones that are only partly in the scene. In a situation like this I sometimes move some of the boats at the drawing stage to create a pleasing composition, but in this instance I felt that they were positioned perfectly. I liked the way the shapes diminished in size, thus reinforcing the perspective that leads the eye from the foreground to the middle distance.

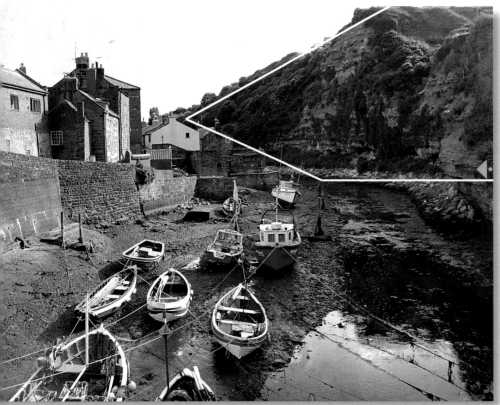

Even though I felt that the basic composition didn't need changing, you can see that there is a big difference between the finished painting opposite and the photograph (left). The sun was getting fairly low, with the result that the cliff on the right was quite dark and heavy in tone. You can see from the painting that I have lightened this side and at the same time simplified it, omitting a lot of the detail, and rendering it in a more misty, unresolved way.

Compare this detail from the photograph and with the detail from the painting, and you can see that the dark foliage on the hillside is very similar in tonal value to the distant buildings. This makes the buildings look like part of the hill rather than several metres in front of it. This strong colour on the hill also brings it forwards, which I didn't want in a background feature, so I painted it in a lighter, softer tone than the buildings, to push it back and prevent it from competing with them. When the hill had dried, I faded it with clear water to enhance the feeling of distance (see Fading colour, page 10).

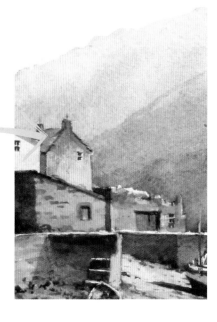

I chose a limited palette of colours to create harmony in the painting, aiming for a much softer, more painterly image than that of the photograph, where the light is more harsh. I thought all the masses of dark green were a little heavy, so I reduced these considerably, but didn't eliminate them altogether, as I liked the way the dark on the bottom of the right-hand bank reflected in the water. I thought the stonework on the left-hand wall and the rocks and stones in the mud added some much needed texture, but rather than paint these with too much detail, I suggested them with a few brush marks, again keeping them soft in parts and slightly unresolved (see right). I noticed from the photograph (see detail) that the stones and mud in this area were covered in moss, so I introduced a hint of bright green.

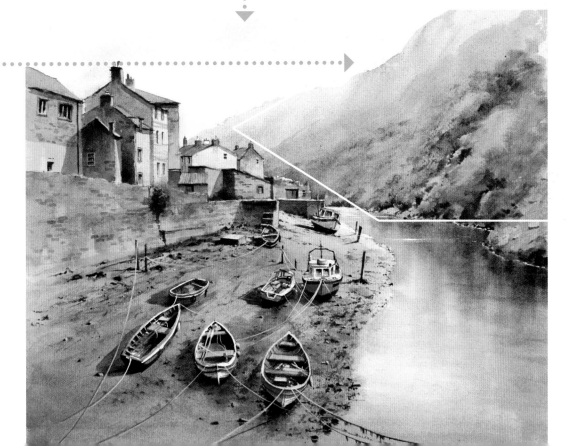

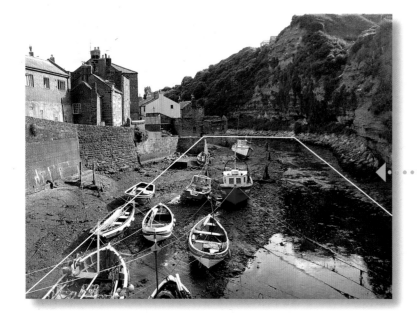

You can see from the photograph (left) that the whole area in the middle of the scene where the boats rest is mud. I often joke to my students that mud is the easiest colour to mix, since in watercolour we often get muddy colours when it is the very thing we were trying to avoid, usually due to over-working. You can see from the painting (below) that I have not attempted to match the mud colour in the photograph, preferring instead to use the same colours as those used in the buildings and stonework, thus preserving that important feeling of warmth and light. I also introduced a touch of blue from the sky in the foreground, to suggest that it is wet. See the Colour mixes opposite.

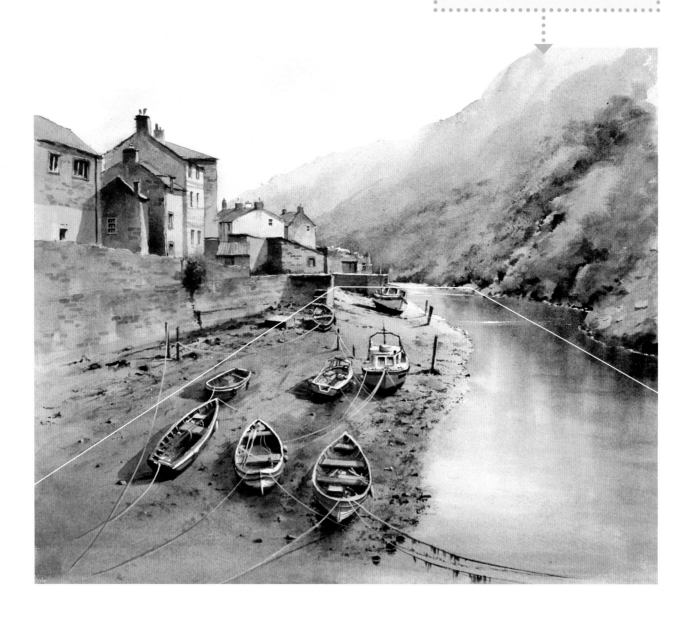

Colour mixes

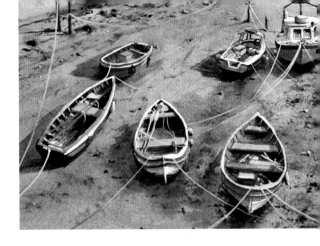

Burnt umber and Naples yellow for the muddy area where the boats are beached, also used on the sea wall and buildings. The hint of green added is a mix of aureolin and cobalt blue.

The brown colour softens into a mixture of cobalt blue and rose madder.

Raw sienna and burnt sienna for the brick-built buildings in the background.

Colours for the boat hulls

Cadmium red

Cobalt blue and cerulean blue

Cobalt blue and viridian

Cobalt blue and French ultramarine

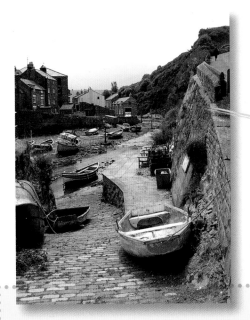

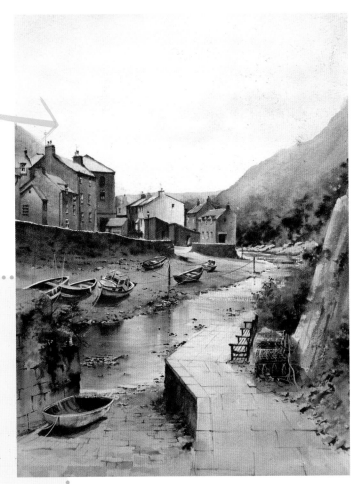

Here is another photograph of the same scene, but from a lower viewpoint, looking down the jetty to the beck and muddy shoreline. If you compare this with the painting I did from it, you can see that I moved in a bit closer, taking out a bit of foreground, and added a bit more sky. I removed the boat from the right-hand foreground, as I considered it acted as a barrier, preventing the viewer from mentally walking down this walk-way towards the jumble of lobster pots and benches, which I felt added some foreground interest.

Lake District Bridge

Ashness Bridge is a narrow packhorse bridge, just wide enough to drive a car over, with an excellent vista across the Borrowdale valley and a view of the lake, Derwentwater, and Skiddaw mountain in the distance. It is a popular location, with all the main elements placed perfectly in a natural composition that needs very little changing to make a good landscape. I am not alone in thinking this, as it is favoured by artists and photographers alike, adorning many a calendar and cropping up on the walls of galleries all over the area.

I prefer this subject in the winter or early spring, as in the summer the view is partly obscured by the dense tree foliage. I have always thought that I would love to paint it as a snow scene, but reaching this vantage point in snow without a four-wheel drive vehicle would be very difficult. I therefore decided to adapt a photograph taken in less challenging conditions.

I used the photographs below that I had taken a few months earlier in April, when most of the trees were still bare. It is much more difficult to convert a photograph taken in summer to a snow scene, with a lot of the detail hidden by the abundance of greenery. Because I was using the photograph mainly for detail and information, I needed to employ some imagination and educated guesswork to depict it in its winter cloak. I decided to include this bit of 'cheating' in this book, as I suspect many readers may also find it difficult to travel to their favourite locations, when winter has us in its grip.

You can see from the photograph that the light was not particularly good, the dull conditions making it look a bit flat and uninspiring. My wife and I are very fond of walking, and I always take my camera along, looking for good painting subjects. If the light is not particularly good, I still take photographs, as I might be able to use them at a later date; but of course I much prefer to be out and about on a bright day, and always get more potential material when the light is better.

I decided to make the scene a longer, panoramic format by joining two pictures together, so that the bridge would look like part of the wider landscape, rather than like a picture of a bridge, with a bit of incidental landscape.

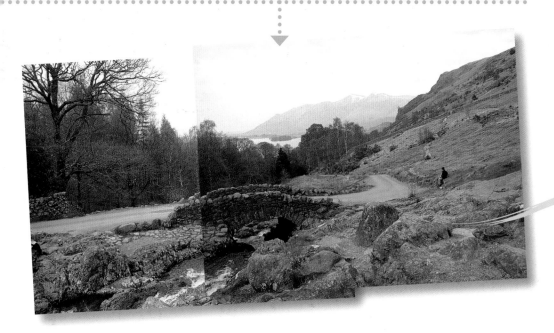

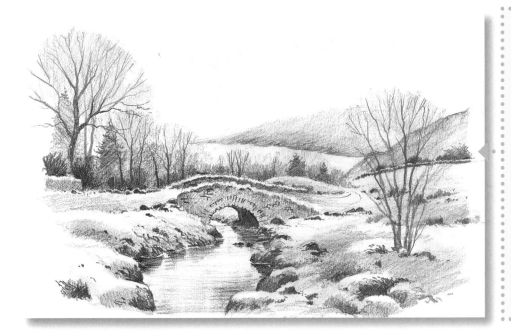

In order to help me to get some idea of how I could change the photograph into a snow scene, I did this pencil sketch. This gave me an idea of how the landscape could look with the shapes simplified by the white coating. I also find doing a sketch like this very useful for exploring the composition and establishing the tonal values by placing the lights, mediums and darks.

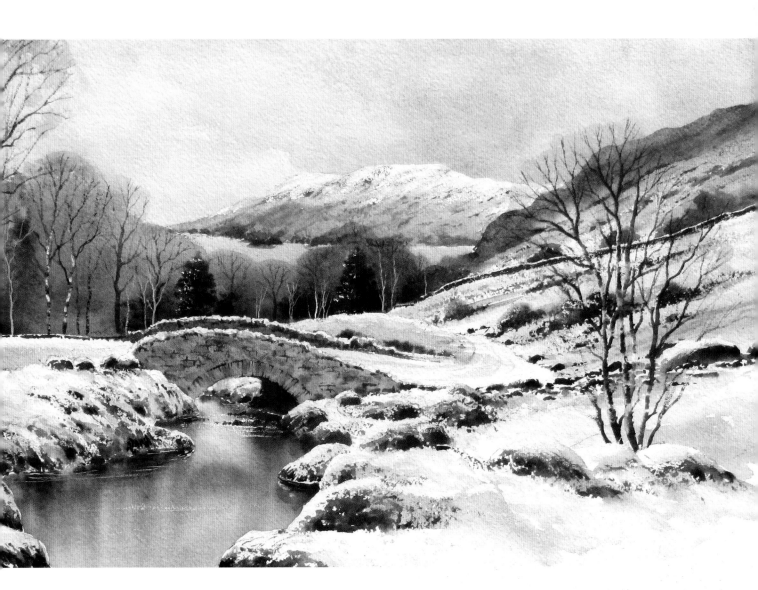

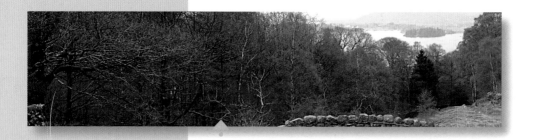

If we compare the finished painting (opposite) with the photographs, you can see that, despite it being a winter scene, I have tried to inject some bright light and warm colour into it, producing a much more lively, painterly scene. Just because it is a snow scene doesn't mean it has to feel bleak and make the viewer shiver. You can see from the photograph detail (above) of the strip of trees across the middle distance that the colour in this area is predominantly a cool grey. Compare this with the same area in the painting (detail below) and you can see that I have used more variety of colour, introducing warm browns, greens and a hint of purple.

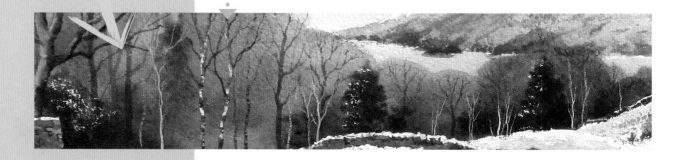

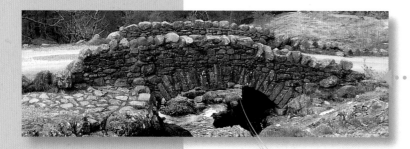

The same applies to the bridge, where instead of the rather dull grey on the photograph (see detail), I have introduced a variety of colours into the painting (see detail). See also the Colour mixes opposite.

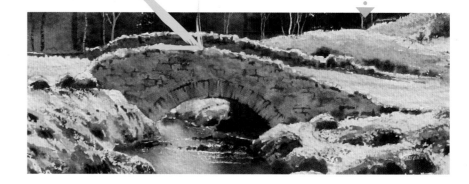

Colour mixes

Stonework colours

A thin wash of raw sienna with a purple made from cobalt blue, cobalt violet and cerulean blue and a green made from aureolin and cobalt blue brushed into it. Used for the wall and bridge.

Colours for the trees in the middle distance

Dark green mixed from viridian, ultramarine and burnt sienna

Cobalt blue and cobalt violet

Raw sienna and burnt sienna

Bright green mixed from aureolin and cobalt blue

Burnt umber

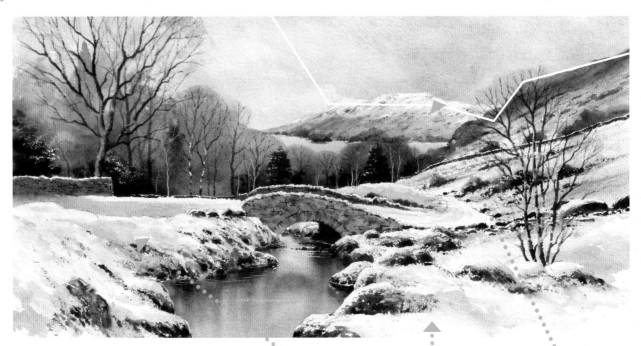

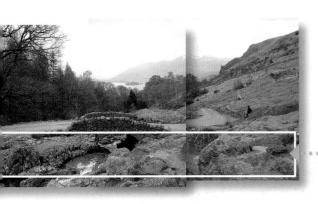

The foreground is a very busy area in the photographs, but you can see how I have simplified this, applying washes of shadow colour to indicate the undulating nature of the terrain under the snow. I carefully chose certain areas to show the dark of exposed stones and rocks, particularly near the beck.

I darkened the sky to the right to give me some contrast, bringing out the white of the snow on the top of the distant hill.

Venice

Despite having visited Venice quite a few times over the past ten years or so, I can still find fresh painting subjects whenever I go there. I love to explore all the little alleyways and waterways, pausing on bridges to take in the views between the walls of the houses and apartments, with their weathered stucco and rustic brick and stonework. I particularly like the interplay of light and shadow on these textured surfaces and the fascinating variety of shapes provided by the windows, doorways and verandas.

Having printed out the photograph shown below, I felt that it was just right without any compositional changes. I did feel however that the modern power boat on the left did not add anything to the composition, and lined up too much with the gondola on the right, becoming a distraction. I also felt that it took away some of the romance we associate with Venice, where we expect to see traditional craft piloted by gondoliers, slowly punting their passengers along the ancient waterways. This is a personal decision however, and not a case of right or wrong, as the motor boats are part of modern Venetian life, in the same way that cars are now an intrinsic part of street scenes all over the world and I don't think it is necessarily wrong to include them.

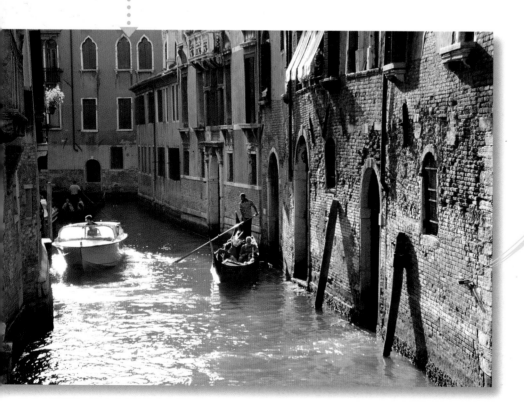

You can see that the finished painting below has a softer, more painterly look than the photograph. This is achieved in part by not getting bogged down with too much detail during the painting process, and by using unifying washes in the initial wet-into-wet stage. In this case I laid a mauve wash over the far distant building, followed by a light wash of quinacridone gold over the rest of the paper including the walls of the buildings and the water. Before laying these washes, I applied some masking fluid to the awning in the top right, and to the bright white areas created by the light catching the ripples on the water in the left-hand middle distance and foreground.

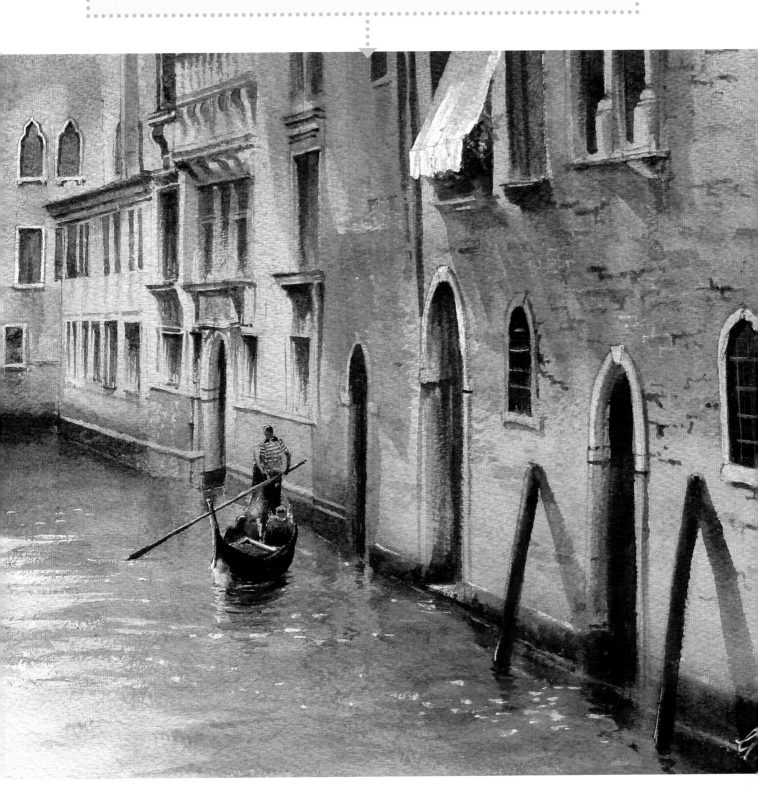

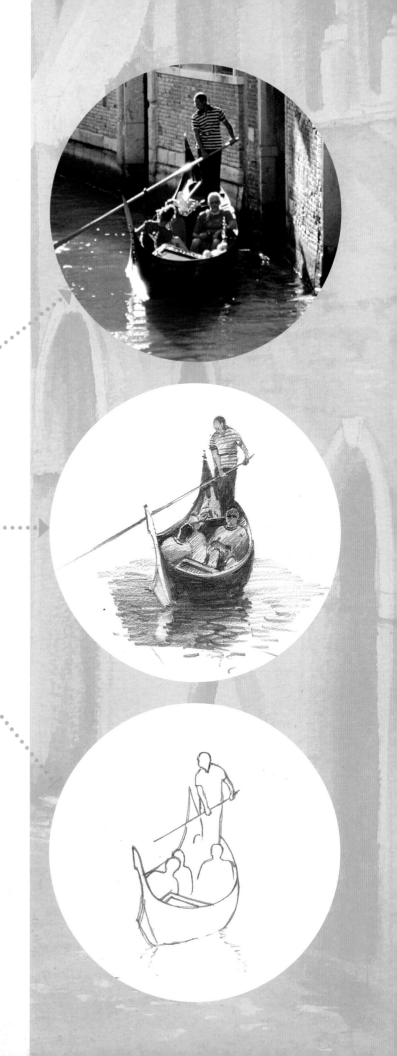

As with any figures in a painting, you have to get the shape and scale correct or they can ruin an otherwise good painting. I therefore took extra care by enlarging this part of the photograph (right) and doing a pencil sketch of the figures (see below left) to help me to better understand the position and shapes, particularly the stance of the gondolier. If you plan the size of this sketch to the same proportions you intend to make the painting, then once happy with it, you can trace it (see below right) and transfer it onto your watercolour paper, in readiness for painting.

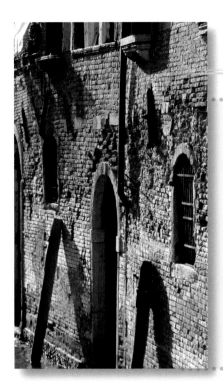

The detail photograph (left) shows that I simplified the brickwork in the painting (right). In the photograph, you can virtually see every gap in the mortar and the rustic detail of every brick. I have conveyed this weathered look by suggesting a few brick shapes, with a few dark and light marks for the mortar and the odd place where it is missing. I have used a warmer shadow colour in the painting, choosing a transparent mauve (see Colour mixes, below), which contrasts well with the warm reds and yellows in the wall.

Colour mixes

Cobalt violet with a touch of cobalt blue for the distant building.

Burnt sienna and French ultramarine for the darks.

Cobalt violet with cobalt blue for the shadows.

The water is made up of colours from the buildings, with cerulean blue added to create the impression of murky water.

Quinacridone gold and burnt sienna for the walls.

When it comes to painting a body of water, I would usually base the colours on those in the reflections. This could be the sky, surrounding countryside or as in this case, surrounding buildings. However, as you will know if you have visited Venice, the water does not have a very clean, bright look, appearing instead a bit murky and green. I was helped to achieve this, by the fact that I had used quinacridone gold in the initial wash covering walls and water alike. This meant that as I introduced touches of the colour from the surrounding walls into the reflections, I also added a hint of cobalt blue which, when glazed over the underlying yellow of the quinacridone gold, creates a green tint.

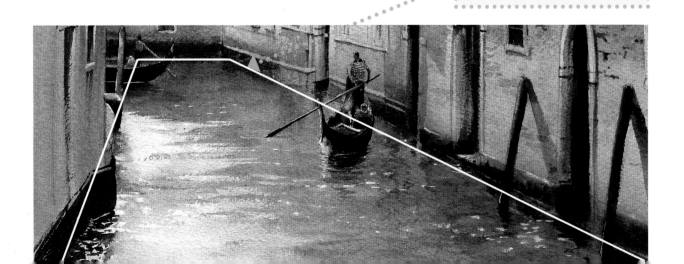

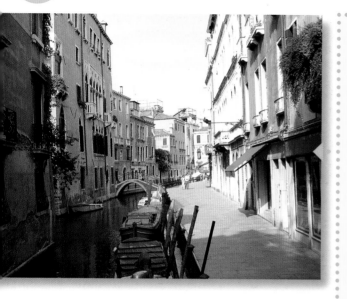

On another Venice trip I took the photgraph (left) where, because the street is wider, it is more open to the sky, making the light brighter and a little harsher than in the previous scene on page 90. Because of the angle of the mid-afternoon sun, the light is very strong on the right-hand side of the scene, leaving everything on the left-hand side in quite strong shadow. For this reason, I decided to crop much of the left-hand side, creating a square format (see below). While this square shape departs from the more traditional, rectangular landscape format, I like it and from time to time choose it as an alternative. You don't have to use any software to crop your photograph in this way; just print it as it is, then fold it, cut it, or use a strip of masking tape. I particularly liked the second bridge in the distance (within the white square), the diminishing size of which provides good perspective. This is an argument for printing your photograph quite large – I usually print them at least A5, sometimes A4 (letter size), as in a small size print, this second bridge could easily be missed.

In the finished painting (opposite), you can see that I chose to make the reflections in water in the bottom left a bit brighter than they appear in the photograph. I also chose to change the colour of the tarpaulin on the very foreground boat from blue to a viridian green. I think this adds an important splash of colour that represents a stronger statement than the blue would have done, and contrasts effectively with all the earth colours in the buildings.

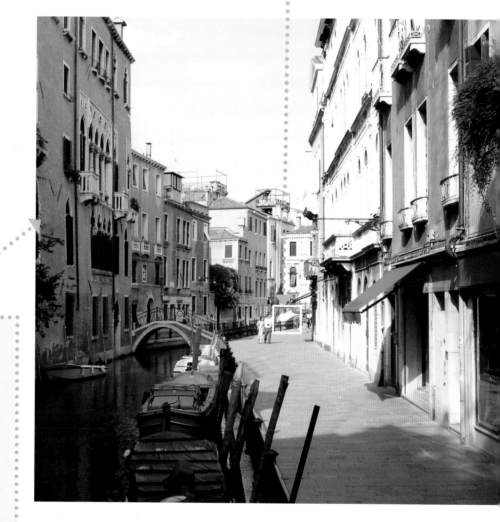

The overhanging foliage at both the left- and right-hand sides, and the small amount glimpsed beyond the footbridge, offers us a soft shape that contrasts well with all the surrounding harder, manmade shapes. This whole painting was completed with a limited palette of just six colours, which really makes it hang together.

This painting is considerably older than the one on pages 90–91, and looking at it now, I wish I had made the distant buildings slightly lighter in tone and softer; but that is all part of the learning process and it shows that it is a good idea to photograph your paintings, enabling you from time to time to revisit your earlier work and remind yourself of the progress you might not have noticed you are making.

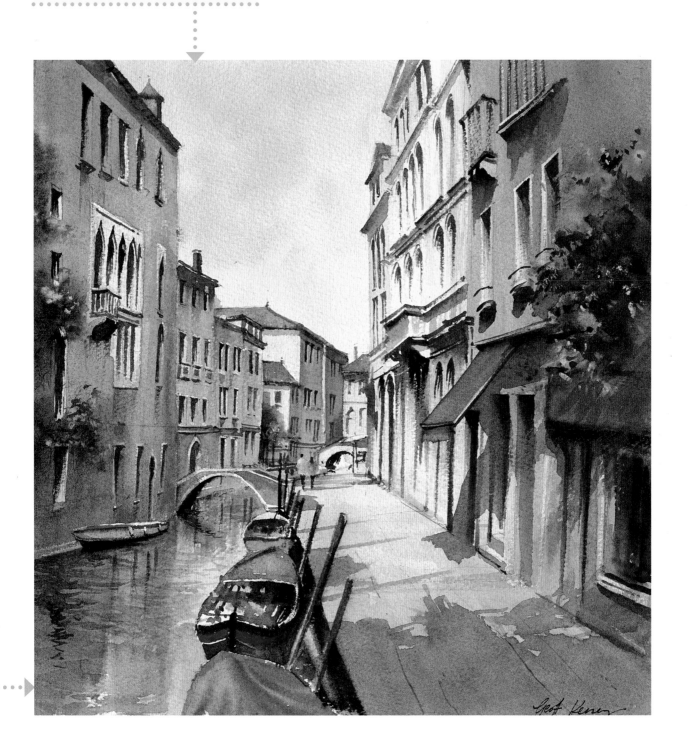

Seaside Village

Sometimes the inspiration for a painting comes from an unexpected source. I got the idea for this painting of Portloe in Cornwall when watching a TV comedy series called 'Wild West', centred around a small fictional community living on the Cornish coast. The programme showed plenty of views of the village and its setting, but didn't disclose the exact location in any of the credits. After a bit of research, however, I discovered it to be Portloe, which I made a mental note to visit when we were next in the area.

We approached Portloe on a lovely sunny afternoon, along the cliff path that you can see at the right of the photograph below, which, after visiting a few other vantage points, I still felt afforded the best view. I was particularly attracted to the focal point of whitewashed buildings nestling in the cove.

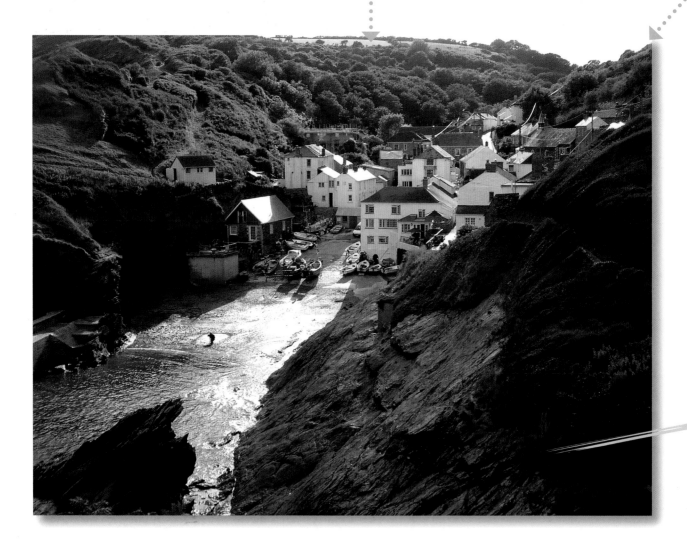

This compositional diagram shows that I have employed the basic rule of thirds when composing the photograph (see Composing from photographs, page 13). I often do this by instinct, but if that doesn't come naturally, it is worth applying this imaginary grid in your mind's eye. Obviously you can change the composition at the painting stage if it isn't quite the way you want it, but it can make the job easier if you consider this when pointing the camera.

Here we can see the focal point of the buildings is contained in the top right-hand third of the scene. This also creates an 'L' shape down the left-hand side and along the bottom which helps to frame this vital focal point and draw the viewer's attention to it.

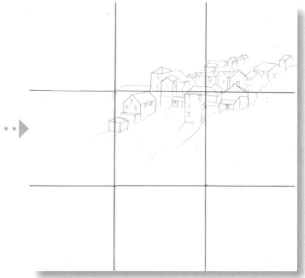

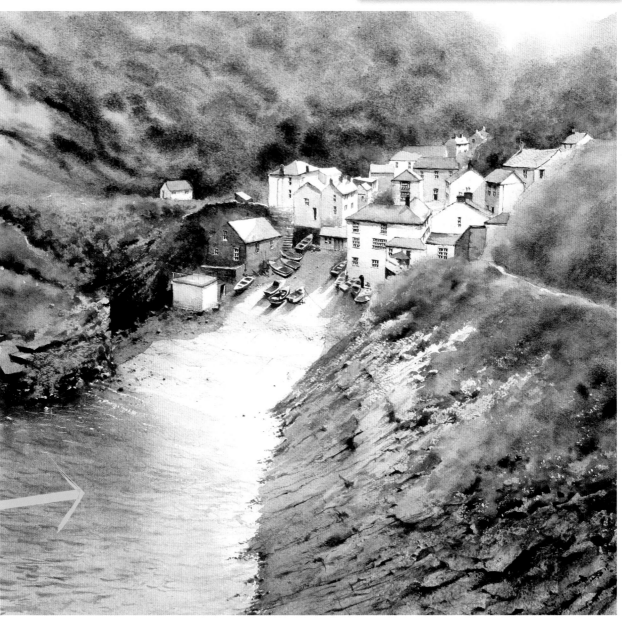

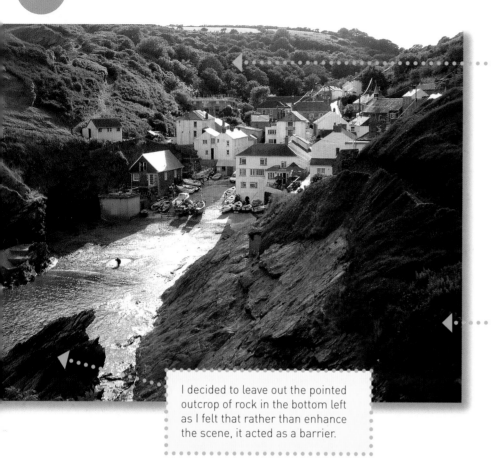

With such excellent reference material, I did not feel it was necessary to make many changes. I have however endeavoured to soften and simplify the subject, particularly in the distance. Compare the distant trees behind the buildings in the photograph, where they are much more clearly defined, with this area in the painting. Here you can see a much softer, unresolved look, which I think contrasts well with the harder shapes of the clustered cottages.

I cropped the scene slightly at the left and right, to give me a more square composition. It would have worked perfectly well as a rectangle, but occasionally I like to vary the size and shape of my paintings.

I decided to leave out the pointed outcrop of rock in the bottom left as I felt that rather than enhance the scene, it acted as a barrier.

Colour mixes

The biggest difference in this scene between photograph and painting is the colour. In the furthest distance (top right) in the photograph, the colour of the trees is very similar to the rest of the foliage in the scene, including that in the right-hand foreground. In the painting, however, I painted that part of the scene in a cool grey, gradually introducing the stronger, greener colours as we proceed towards the middle distance. I was careful not to make the painting too green, as sometimes this can feel a bit monotonous and flat, preferring instead to introduce other colours like warm browns, reds and yellows.

A cool grey for the distance and the sea, mixed from cobalt blue, cobalt violet and burnt sienna.

Brown for the distant hills mixed from burnt sienna, French ultramarine and cobalt violet.

A muted orange-brown for the background hills, mixed from raw sienna and cobalt violet.

A cool green for the distance and the sea, mixed from viridian and cobalt violet.

Green for the hills, mixed from aureolin, cobalt blue and raw sienna.

Dark green used sparingly in the foliage, mixed from viridian, French ultramarine and burnt sienna.

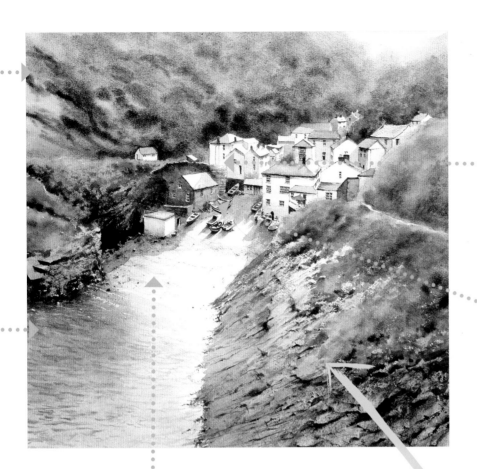

If you compare the buildings in the photograph with those in the painting, you can see that there is an element of simplification, but not too much, as I wanted this to be a more detailed area that contrasted with its natural surroundings.

I thought the little clusters of distant boats added interest to the focal point, and gave me the opportunity to introduce a few contrasting colours like blue and red.

One cue I took the from the photograph was the brilliant light in the centre, caused by the sun reflecting on the wet slope and shallow water, sandwiched between the cliffs on either side. This was achieved simply by leaving white paper. I aimed to have an overall lighter feel in the painting than in the photograph.

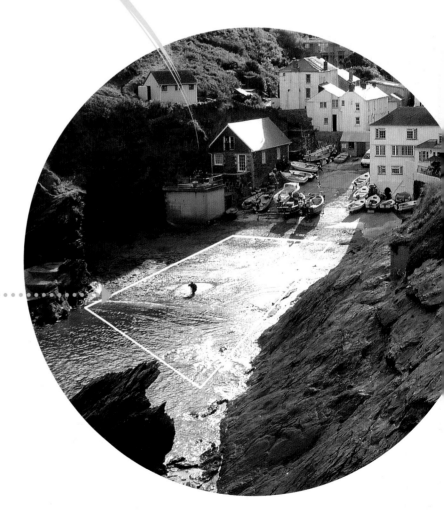

Peaceful Stream

It is a good idea when you are out with your camera looking for potential painting subjects, to try and find a more unusual viewpoint and shape. This helps to guard against your paintings becoming too formulaic and repetitive. This view of Watendlath Beck in the English Lake District is a wider format than most landscape paintings.

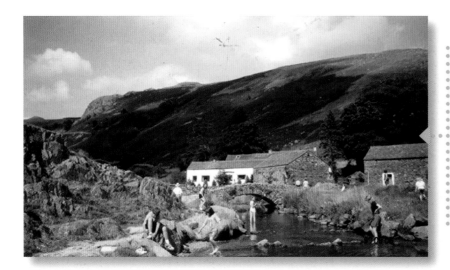

This scene works perfectly well in the traditional format you can see in this photograph, where the length is approximately 1.5 times the height and the focal point of the bridge is in the bottom third of the scene, with the hills behind it and the sky above that.

However if we look at this alternative view, the format is more panoramic: the length is more like 2.5 times the height, and the focal point is in the top third of the scene. This means we have a lot more foreground – not always a good idea in my opinion, but in this subject I think it works, as I like the dark reflections in the widening beck, contrasted with the very light-coloured shingle.

This composition means we have virtually no sky; instead the relatively dark tones of the trees and background hills provide us with an excellent counterchange to the light on the buildings.

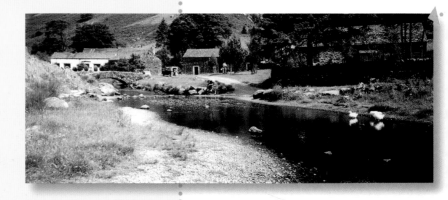

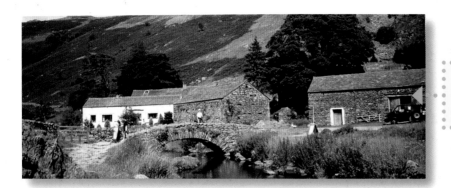

I took this third photograph to give me some close-up detail of the buildings.

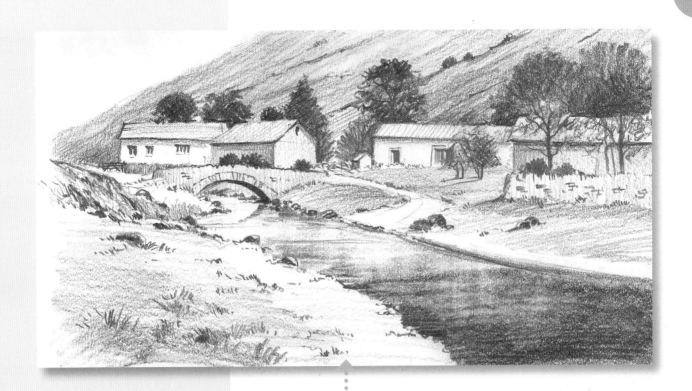

I did the above sketch to make sure I had a firm grip on the composition and tonal values. These tonal values were particularly important, as if you look at the painting (below) you can see how the rich darks contrast with the warmer, much lighter colours of the path, bridge and buildings.

I thought it was particularly important that the buildings should not all have equal prominence in the scene, so I used the cue from the second photograph and partly hid the right-hand ones behind the trees.

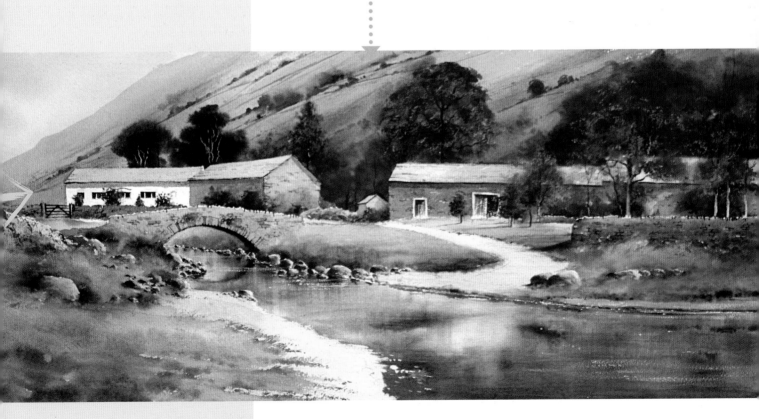

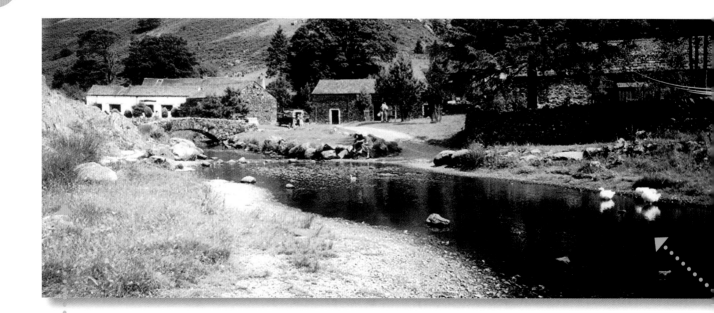

If you compare this far right-hand area of the scene on the photograph with that of the painting opposite, you can see that I have cropped this area a bit, reducing the length of the wall. This made the length of my painting approximately twice the height rather than 2.5 times as it is on the photograph. It wasn't absolutely necessary to reduce the length, but I felt it made a more comfortable shape for viewing.

Apart from these few changes, I stuck fairly closely to the subject as it is in the photograph. There is no need to make changes for their own sake.

Looking back now at the painting, I wonder if I should have added a few signs of life; maybe a couple of people walking to or from the bridge, or even the ducks in the right-and foreground of the photograph. I also think the glimpse of white paper left along the top of the stones to suggest the light catching them is a bit too stark and I should have tinted it slightly. This is one of the reasons for photographing all your paintings before you frame them; it enables you to learn from your mistakes and gradually improve.

As the beck is very slow-moving, I painted vertical reflections, but added a touch of white gouache to suggest ripples (see the detail above). You can see that I used the same limited palette of strong colours in these reflections that I used to paint the rest of the scene to give the painting harmony and continuity. See Colour mixes, opposite.

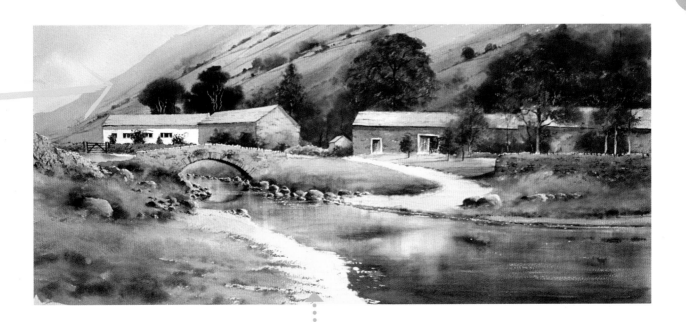

You can see that on the photograph opposite that the stonework is quite grey, whereas in the other photographs on page 100, it is a warmer colour, because the sun is brighter. I have chosen the slightly warmer, yellowish hue for the painting to emphasise the feeling of sunshine. The white-washed building on the far left gives us an important variation, and the tonal contrast it creates really draws the viewer's attention to this, the focal point.

If you compare the photographs with the painting, you can just glimpse the roof of another building behind the ones just behind the bridge. I left this one out as I felt it didn't add anything to the composition and was more of a distraction.

Colour mixes

Cobalt blue with a touch of phthalo blue, used for the sky, shadows and slate roofs.

Aureolin, cobalt blue and raw sienna; a yellowy green for the grass, which is less verdant because it is growing through shingle.

Phthalo blue and burnt sienna; a dark green for the trees and reflections.

Burnt umber on the central building and the buildings partly obscured by trees.

Naples yellow and burnt sienna for the stonework of the buildings and bridge.

Hamlet Bridge

A few years ago, while having a few days' holiday in North Yorkshire, we took a train ride from Grosmont to Goathland, then returned to the starting point on foot, following a popular walking route, much of it along the track bed of the original Whitby to Pickering railway line. Along the way, we came across this tiny little hamlet called Beck Holes, and after a bit of exploration, I found the scene you can see in the photograph below.

I knew that the overcast conditions were not ideal, making the light in the photograph a bit flat. I would also have preferred the scene in the winter, as much of the detail that made the subject interesting was obscured by the abundant summer foliage. As I have stated previously, I am not a fan of too much green, though this is a personal opinion, not a case of right or wrong. It was a long wait for the winter, however, so once I had printed the photograph, I examined it and decided that with a bit of guesswork and imagination, I could depict this scene in winter, taking cues from what detail I could glimpse between the trees and bushes. The colour palette would not be a problem, as I could see the colour of the stonework and pan-tile roofs and could fall back on my experience of painting winter scenes, to put together a limited range of colours which would complete the rest of the picture.

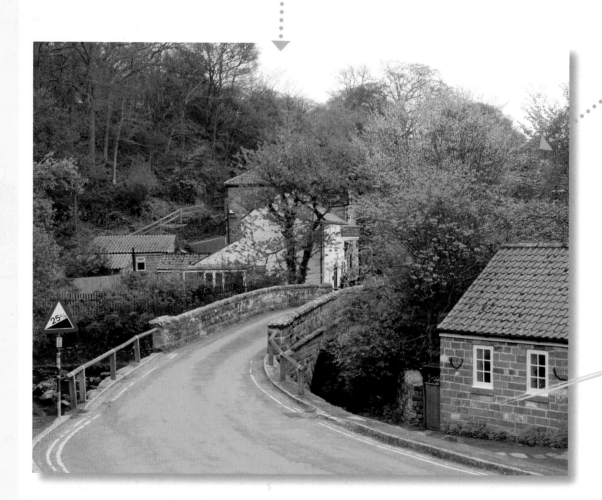

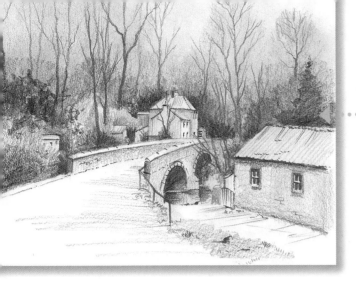

Before committing pencil to watercolour paper, I did this sketch to help me convert the scene to winter and sort out the composition.

To get the detail for the focal point, the white-washed house and building next to it, I enlarged this section of the photograph (see right). This enabled me to make out the basic shapes, but I did have to guess at some of the detail, and I realise it may not be 100% accurate.

The trickiest bit was to guess the second arch of the bridge, which in the photograph is totally obscured. However, I was able to get round this by moving in a lot closer to take this photograph, which although it was from a slightly different angle, gave me sufficient information to put in both arches.

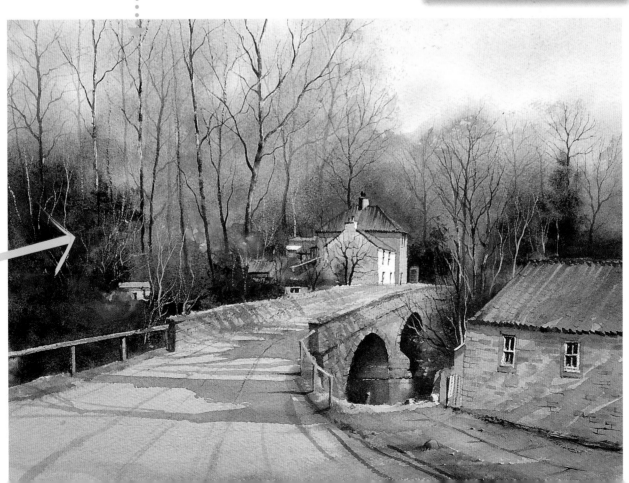

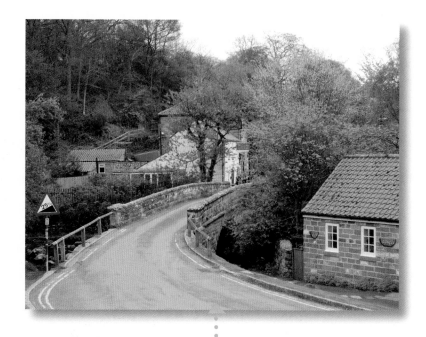

If you compare the photograph with the finished painting, you can see that I have closed in on the scene, moving nearer to the bridge and losing a bit of foreground. I preferred this as I felt the bridge and the buildings just beyond it needed more prominence, whereas the road in the foreground was not particularly interesting. I was careful to include the cottage in the bottom right as it provided useful foreground interest, and if you compare this with the buildings in the middle distance, you can see that I have put more detail into the nearer cottage – stonework and roof detail – whereas in the further buildings, details like this are just suggested. This helps with the feeling of distance, as we would expect to perceive more detail on something that is closer to us. I left out the road sign and post box, but included the telephone box, which I felt added a splash of colour next to the focal point.

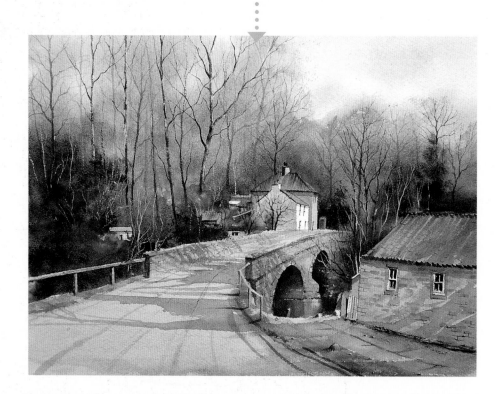

Colour mixes

I felt that the white of the cottage beyond the bridge was essential, so I left it as white paper, with just a hint of grey shadow. I wanted a bright, warm orange for the pan-tile roofs, to contrast with the more muted brown and grey colours in the background, and I chose a couple of dark greens to add to the tangle of bushes and trees which would break up these browns. I chose a warm grey for the stonework and the road.

Indian yellow and light red for pan-tile roofs.

A dark green mixed from viridian, French ultramarine and burnt umber.

Raw sienna: a warm colour for stonework.

A warm grey mixed from cobalt blue, rose madder and burnt sienna.

Raw sienna and a touch of cobalt blue: a cooler, greyer stone colour.

A rich, dark brown mixed from burnt sienna and French ultramarine.

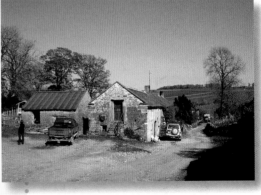

Here we can see another example of using a photograph taken in one season as inspiration for a painting set in a different season.

In this example, One Ash Grange in the Peak District, UK, the photograph was taken in April, so there was very little foliage on the trees and it was not too much of a stretch of the imagination to depict them in their winter form.

I kept the car in the picture but moved it a little further down the track to reveal a bit more detail around the base of the building.

In the middle distance on the photograph, I could just make out a barn behind the tree on the right, so I made more of this with a bit of guesswork. I also reduced the size of the fir tree in the middle distance to reveal more of the roof on the building to the left of the track. I felt this fir tree added a useful touch of dark green, and a good contrast to the surrounding snow-covered roofs and distant fields.

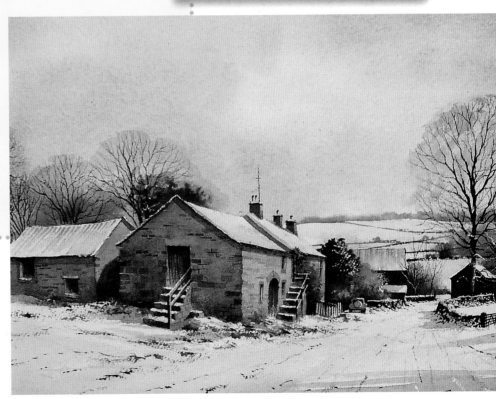

Wooded Gorge

Padley Gorge is a deep narrow valley running through an ancient woodland that belongs to the National Trust. It is one of the Peak District's most popular footpaths, enjoyed by walkers all year round, who enjoy the varying terrain as they wind their way along the steep woodland path to the top, where it opens up into parkland and heather moorland.

I took the photograph on a very bright October morning, knowing immediately that it would make a good painting. It is not the sort of subject that benefits from careful depiction of detail; it is all about light and atmosphere. I decided to crop it a little at both sides, making it a squarer format and focusing more attention on the gate.

I did a quick thumbnail sketch to get a grip on the composition (right). While this scene is full of trees, it is important not to paint the shapes as individual trees, but trees en masse, represented by amorphous shapes bathed in soft light and warm colour. However, I felt that without any clearly defined shapes, it would look almost abstracted, so I defined the two dark green fir trees a little more. I also made good use of the five-bar gate, the dark wall to the left of it, and the small building just beyond this, to create a focal point.

I didn't invent the building, as it is just visible among the trees, but I defined it a bit more clearly. This area makes a good focal point: carefully positioned just left of centre, and approximately a third of the way up from the bottom of the picture. The path leads the viewer's eye to the gate and beyond, where it disappears behind the large fir tree.

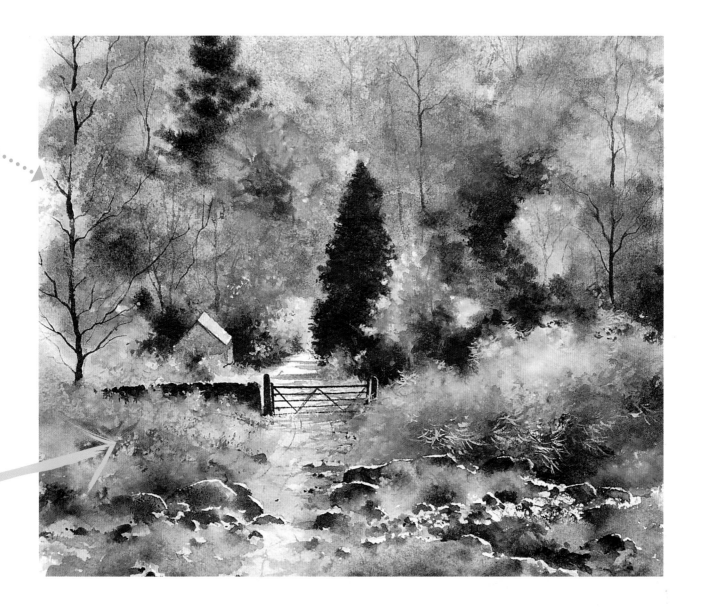

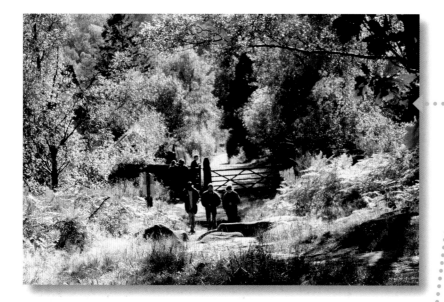

I made good use of the strong tonal contrasts in the photograph to maximise the feeling of brightness in the painting. This is particularly noticeable in the area shown in the painting detail (below), where a sunlit tree is placed in front of the dark green fir.

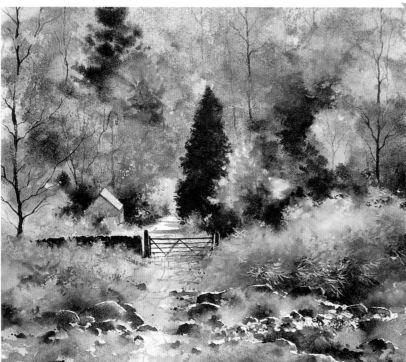

On completion of the painting, I felt that because I had kept it simple and worked loosely, I had captured the freshness of a bright autumn morning, almost as though it had been painted *plein-air*.

I left a very thin line of white paper along the top edges of the stones in the foreground, which further emphasises the brightness of the light (see detail below).

Colour mixes

An autumn gold mixed from aureolin and light red.

A bright green mixed from aureolin, cobalt blue and a touch of raw sienna.

Lemon yellow and nickel titanate – a less acid version of lemon yellow.

An autumn red mixed from light red and cobalt violet.

A dark green mixed from phthalo blue and burnt sienna.

Cobalt blue and cobalt violet, for the glimpse of distance at the very top of the painting, and the shadows on the path.

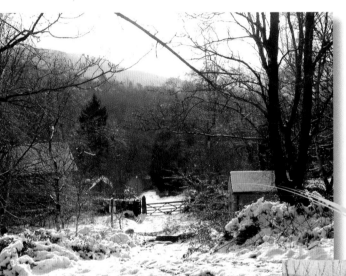

Here you can see a photograph (taken standing a little further back) of the same scene in winter, with a coating of snow, together with the painting I subsequently did from it. You can see on close examination that it is the same place, but the different season has changed it drastically, revealing more detail like the building on the right of the path.

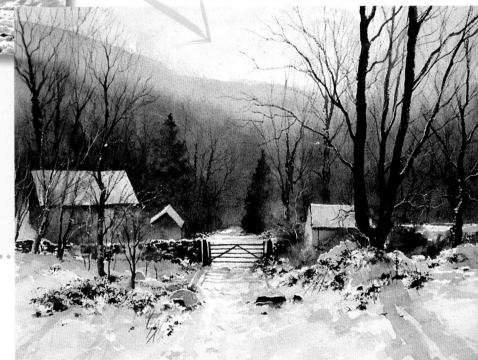

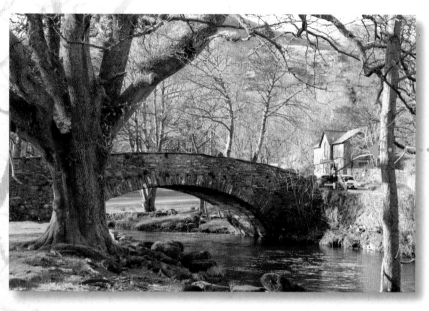

River Bridge

I took the photograph below on a sunny afternoon in March beside the River Rothay in Cumbria, UK. I was attracted by the mellow light and the warming effect it had on the wintry landscape. I also liked the shape of the large tree on the left, with its long tentacle-like branches, stretching out above the top of the scene and framing the main subject (the bridge). I also took the other photograph (shown above), zooming in on the bridge to give me more information about the stonework detail, and the building we can just make out on the opposite side of the road. Of course you can always get a close-up like this digitally on the computer by cropping the image, but zooming in with the camera gives you more definition and detail, and most inexpensive cameras have a reasonable zoom lens these days.

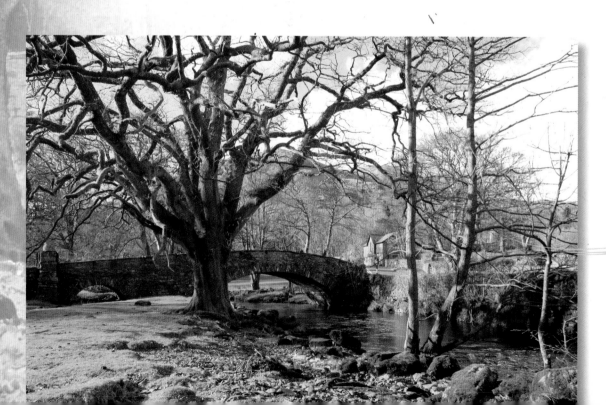

I did this quick pencil line drawing to establish the composition; deciding at this stage to move the large tree a bit further to the left, so that it didn't obscure the left-hand side of the main arch where it meets the ground. I also left out the two trees in the right-hand foreground, as they obscured the view and spoilt the L-shaped composition, competing for the viewer's attention with the large tree. Another small alteration was to close the gap between the two arches, so that the small arch was not too near the left-hand edge. I also straightened the two trees you can see just the other side of the bridge, as I felt the left-hand one was a bit too curved and the right-hand one leaned a bit too much. It is not that I think I can do better than nature, it is just that sometimes viewers don't question something on a photograph, whereas they might consider in a painting that the artist has got it wrong if rather jarring details like these are included.

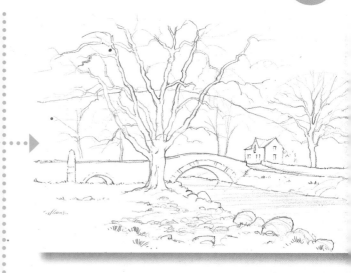

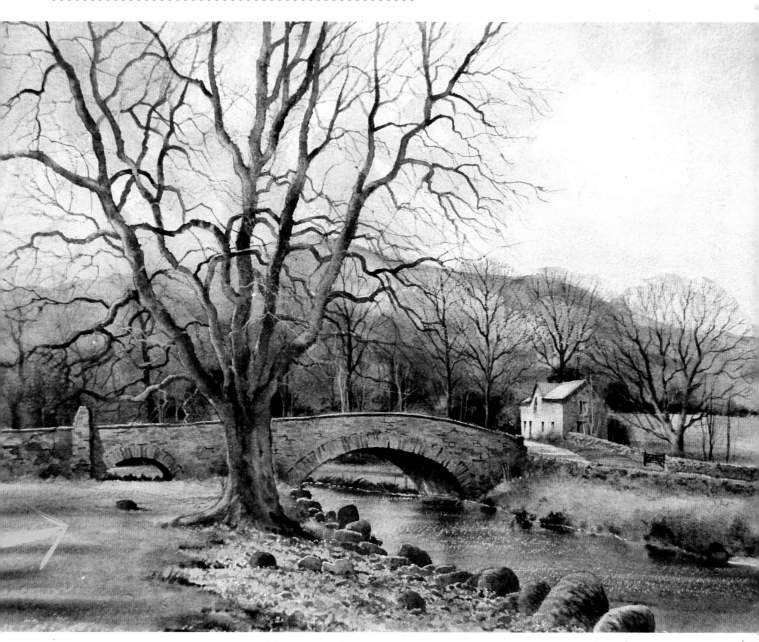

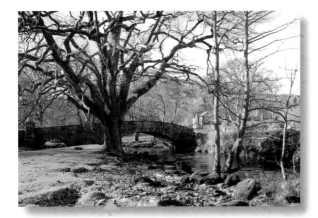

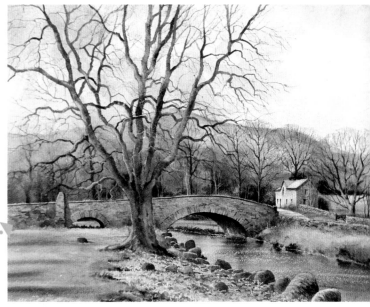

I have slightly lightened the colour on the bridge in the painting compared to the photograph. This was to create a bit more contrast between the bridge and the background, because in the photograph, the low angle of the weak sunshine almost made the bridge a silhouette. I left a tiny line of white paper along the top of the bridge to suggest the light catching it, then I tinted this with a touch of Indian yellow. I usually tint these highlights, as the white paper is often too stark and can almost look like snow.

In the photograph, much of the very fine branch-work is actually lighter than its background, so I mixed an opaque colour for this using Indian yellow with a touch of white gouache.

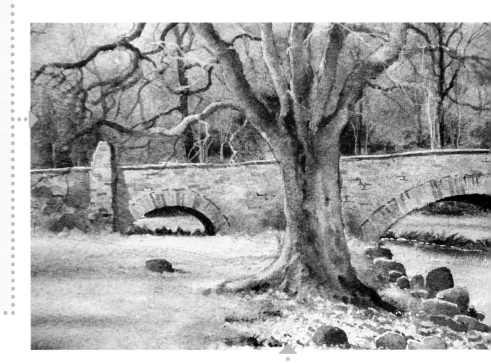

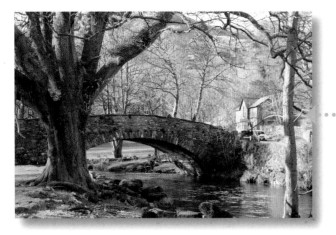

Comparing the detail from the painting above, with the photograph (left), you can see that on the photograph, the tone and colour of the tree is very similar to that of the bridge behind it. To avoid these shapes merging, in the painting I made the tree darker than the bridge. I endeavoured to get the spirit and shape of this tree without copying every branch and twig exactly, which in my experience often loses the spontaneity and can end up looking a bit heavy and overworked. The pencil drawing also helped me to get a grip on the form of the tree.

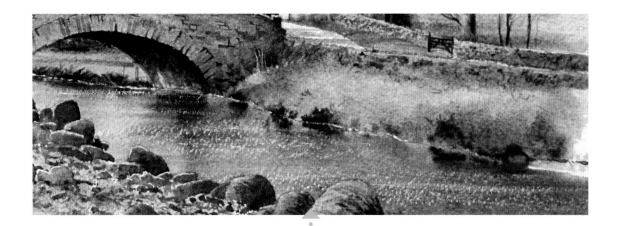

In this detail, you can see that I painted the underside of the arch a rich dark brown, using a strong mixture of burnt sienna and French ultramarine, lightening this into a wash of raw sienna and burnt sienna where it meets the water, to give a suggestion of reflected light. I used the wax resist method (see Using wax resist, page 15) to create the feeling of light catching the slightly disturbed surface of the water.

I painted in the large boulders and rocks, putting a hint of green into them to suggest moss or lichen, ensuring that there was plenty of variation in shape and size to make them look authentic. The shingle area between the rocks and the grass was rendered with dry brush work and just a few irregular marks to suggest the smaller stones and pebbles (see above). It is important with areas like this to leave them partly unresolved, as too much detail can make the foreground appear overworked and fussy.

Colour mixes

Colours used in tree trunk and branches

Indian yellow.

A dark grey-brown mixed from burnt sienna and cobalt blue.

Cerulean blue.

This combination of colours was also used in the bridge, with the addition of cobalt blue and rose madder.

Bright green mixed from aureolin, cobalt blue and a hint of Indian yellow.

Dark green mixed from viridian, French ultramarine and burnt sienna.

Rocky Edge

Curbar Edge is part of a grit-stone escarpment that runs along the eastern side of the Peak District, UK. Very popular with walkers and rock climbers, this whole run of edges with its rocky outcrops and stunning views of heather moorland and rolling hills is also a favoured location for artists and photographers.

As a professional artist, I am constantly searching for the next painting subject, looking for a scene that genuinely inspires me and that feels new and fresh. I have lost count of the number of times I have painted this subject, and I suppose it is what I have heard referred to in art selling circles as a 'potboiler', in other words a scene that sells well. However, I still enjoy painting this subject and on visits to these edges with my camera, I can usually find plenty of inspiration.

I admit that the photograph shown below is not by any stretch of the imagination a good example, as it is old and worn, part of it is under-exposed, and it is quite crudely taped together. Nevertheless, it does contain a wealth of material and I particularly like the viewpoint I got by scrambling down the rocks and looking back up at them, seeing the undersides, with the bare earth, loose stones and patches of dry grass, all contrasting with the lush, purple heather. I also like the way the warm reds and browns in the foreground contrast perfectly with the cooler greens and greys in the distance.

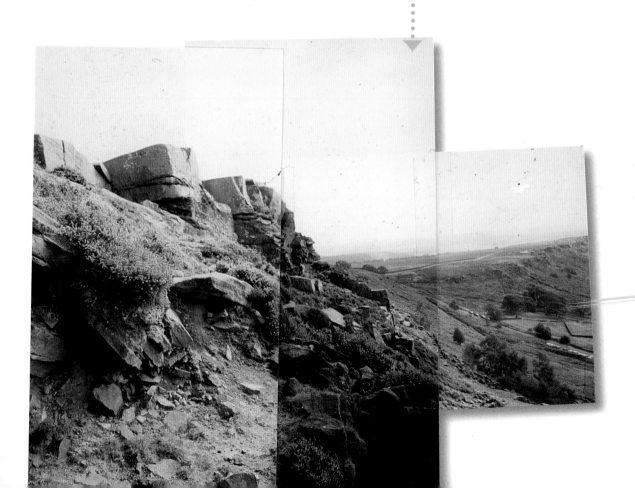

The main challenge with interpreting this photograph was to place the rocks and heather that make up this escarpment in the foreground and middle distance, without them appearing almost as a separate entity to the distance with its cooler, lighter colours. Producing this sketch helped me to get a better understanding of how to merge these areas, and if you look at the finished painting below, you can see that there is a slightly more definite line where the slope of Curbar Edge ends, and the distant fields and next escarpment begin, in the photograph than in the painting. I achieved this by not treating these areas separately; rather I painted through with continuous brush strokes, gradually changing the colours and tones. It helps with this if you don't break down the construction of the painting into too many sections, aiming for a continuing flow.

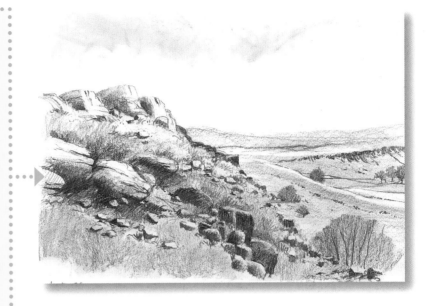

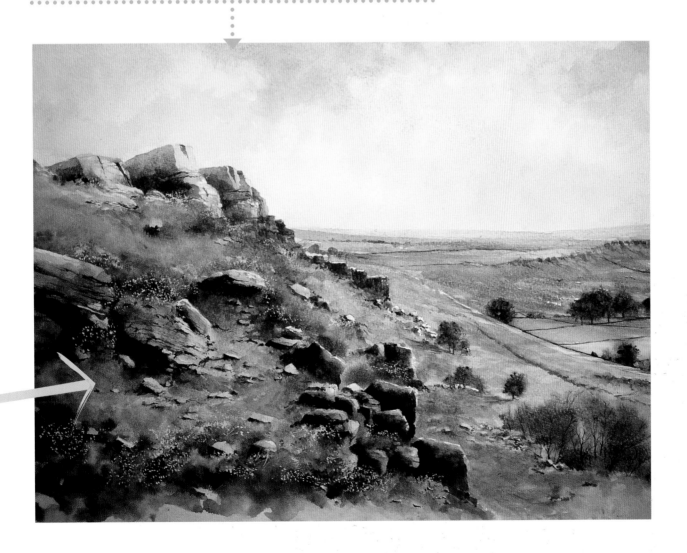

This is an excellent subject for exploring lost and found, hard and soft edges, an effect that watercolour really lends itself to. This is particularly noticeable in this detail, where the hard shapes of the rocks are framed by the softer shapes and colours of the heathers and grasses.

I used masking fluid on the rocks, which enabled me, once it had been removed, to keep a very thin line of almost white paper to suggest the light just catching their top edges.

I made good use of opaque colour to pick out the tiny purple flowers of the heather (see Colour mixes, below).

Colour mixes

Sky colours

Cobalt blue with a touch of light red.

Cobalt blue, rose madder and light red.

Raw sienna and light red.

For the dark shadow under the stones and the earth colour I used burnt sienna, French ultramarine and rose madder. The lighter colour is raw sienna and rose madder.

For the background to the heather and the dark in the rocks I used burnt sienna, French ultramarine and rose madder. For the small heather flowers I used white gouache with cobalt violet, and white gouache with rose madder.

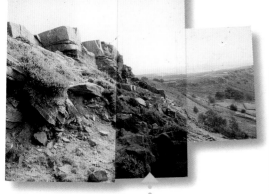

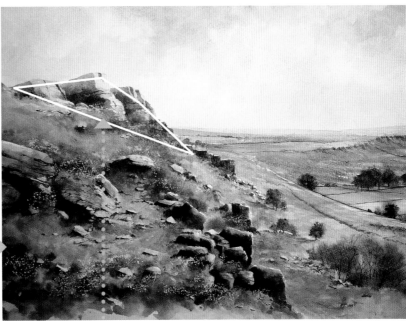

This painting is also a good example of using a limited palette to infuse the whole picture with a harmony and continuity; note how the sky colours are echoed throughout the landscape (see Colour mixes, opposite). The sky in the photograph has little or no detail, but this didn't worry me as I was able to use a bit of imagination to invent a sky, and I made a mental note of the colours in order to echo them in the subsequent landscape.

You can see from the painting that the large rocks against the skyline in the top left are paler in tone and cooler in colour than the ones in the foreground. I was helped to get this effect by the fact that in the photograph, they are slightly over-exposed, prompting me to keep them lighter.

I produced another painting at a later date, using the same photograph as reference material, but this time choosing a different colour scheme. I didn't deliberately change the colours, it was just a case of a different day and a different mood, creating a different result. This illustrates how, when working from photographs, you should not copy them slavishly; better to treat them as a source of information and inspiration, and employ some imagination and artistic license when producing the painting. Indeed sometimes, someone attending one of my exhibitions may particularly like a painting that has already sold and will ask me if I would paint it again. This is not my favourite type of commission, as I feel it is not as creative, but bills have to be paid, so I will often agree to do it. I am always at pains to point out, however, that two originals will never look exactly the same, and I find the best way to approach it is to leave a few months' gap. Then when I work on the painting, I will use the photograph as reference material again but will not look again at the image of the painting they saw on the wall. This way it becomes more of a creative work and less of a copying exercise.

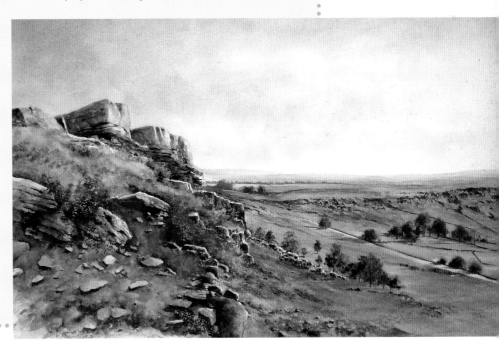

Snow-capped Mountain

I think the reader can easily discern from the preceding chapters in this book, that the English Lake District is a favoured location of mine when searching for painting subjects and inspiration. It was in a little bookshop on one such visit that I came across a book full of excellent photographs of the region, and was particularly drawn to the picture of Great Gable shown here. I bought the book, not with a view to using this actual photograph as a reference, but to use it to find the location and take my own picture.

Photograph reproduced by kind permission of Ed Geldard

Having tracked down the exact location, I took the photograph you can see (right), but I was disappointed with the results. I waited a while so that there was some sunlight in the middle distance and foreground, but couldn't seem to get the right light conditions. Also I particularly liked the shape of the top of the hill, which, in my photograph, was obscured by cloud. I couldn't afford to wait too long for the light to improve. It was also clear that the image in the book had been taken some time ago, and the bridge – which I considered to be a very important element – was now pretty much obscured by foliage, and had a tree growing in front of it.

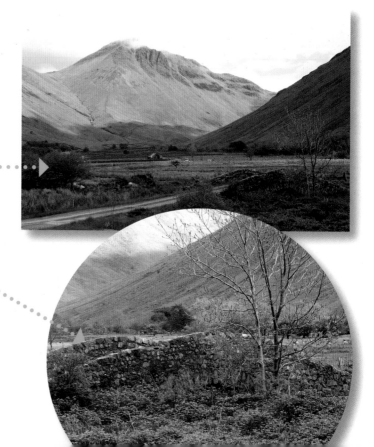

I decided that I wanted to paint the scene using the photograph from the book as reference. Of course, copying other people's photographs has copyright implications, so I contacted the photographer, Ed Geldard, requesting permission to use his image, and he kindly agreed. This didn't mean that I wished to copy the photograph slavishly, but I felt it held much more inspiration and information than my effort. I really liked the its composition: the way the peak of the large dominant shape of Great Gable was just slightly to the left of centre and the slope of the hill in the middle distance pushed the more distant mountains further back. I was determined to emphasise this by darkening the tone on this hill. I was also attracted to the middle distance, where the hills and mountains level out into the valley floor, populated with a criss-cross of dry-stone walls, clusters of trees, and a few isolated buildings. The little bridge was perfectly positioned, a third in from the right, providing vital foreground interest, with the road leading the viewer's eye to it.

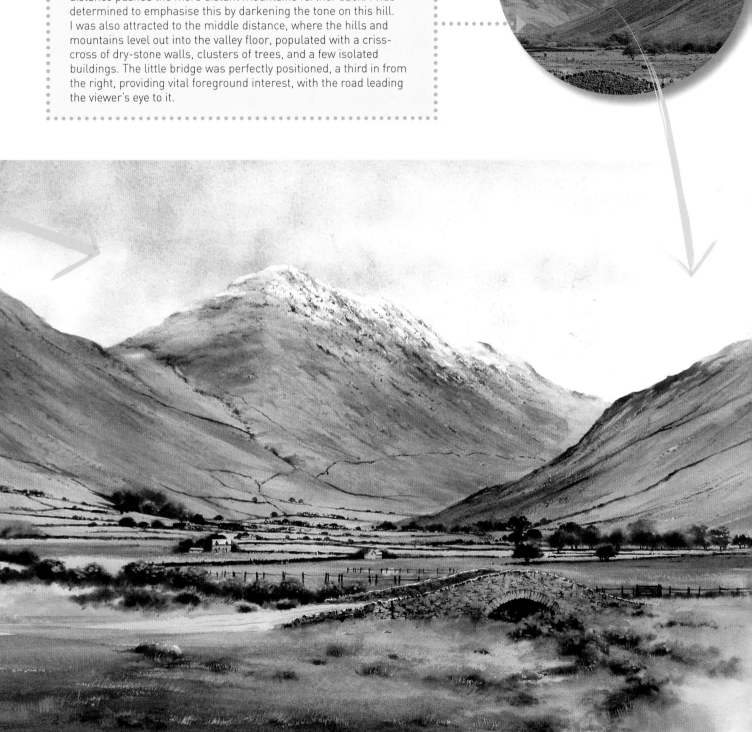

I took the liberty of putting a touch of snow on the peak of the mountain in my interpretation of the scene. I love to see snow-capped mountains and hills, and felt I could get away with it, as on the highest peaks in the Lake District, a bit of snow often lingers into spring. You can see from the detail (above, right) that this wasn't just a case of leaving some white paper, rather I have used blue and purple/grey colours to suggest shadow and scree, leaving just a hint of white paper, highlighted by the blue of the sky immediately behind it. I engineered the sky in this way, since white snow against the white of a cloud doesn't work

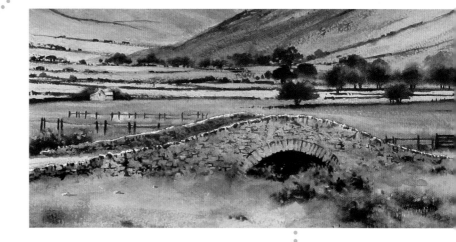

I coated the bridge with masking fluid until I was ready to paint it. Once this was removed, it provided me with a hard edge to pick it out from the background. I emphasised this by leaving a very fine line of white paper, and repeated this to separate the front wall of the bridge from the far wall. I used a rich dark brown mixed from burnt sienna and French ultramarine for the underside of the arch, taking care to soften the colour that represents the weeds and foliage into this dark mix.

It is often difficult to know how much detail to put into foregrounds. No detail at all doesn't really work for me, as this part is supposed to be near where the viewer is standing. Conversely, too many blades of grass and details of flora can look too fussy. In this painting, I felt I had got the balance more or less right, with just a few suggestions of blades of grass and tufts of foliage, together with the occasional stone.

Colour mixes

All the greys in the painting have a touch more red in them than in the photograph, as I prefer warmer, slightly more colourful greys. I loved the way the purple shadows blended into the warm ochre colours in the lower hills and middle distance, which I had chosen in order to avoid using too much green.

Cobalt blue with a touch of rose madder, used for the sky and snow shadows.

Cobalt blue, rose madder and a touch of burnt sienna, used for greyer snow shadows and general shadows on the landscape.

Raw sienna, used on the hillsides.

Aureolin, cobalt blue and raw sienna, used on the hillsides and pastures. An excellent all-round green.

Viridian, French ultramarine and burnt sienna; a dark green for foreground shadows and middle distance trees.

One thing we need to consider that a photograph does not always provide is the use of tone to create a feeling of distance. Compare the detail from the photograph (left) with the finished painting. You can see that although the more distant hill is much further away, the colour and tone are not much different. In the painting, I have used tonal values to describe this distance. No matter how good the photograph is, it will still require some interpretation by you, the artist.

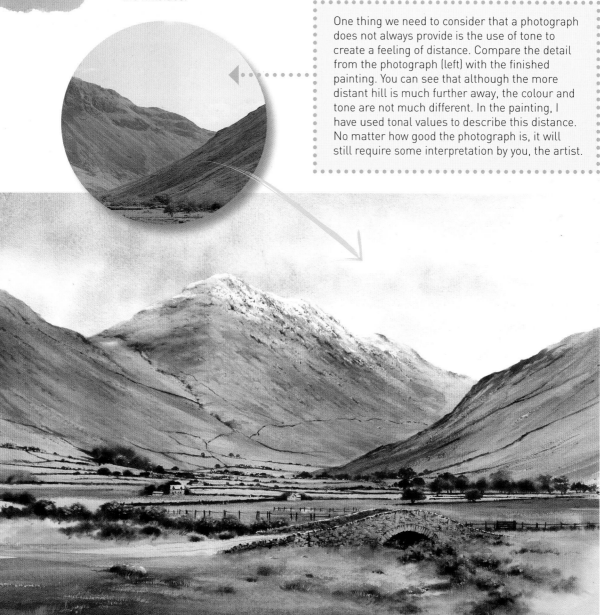

Over to you

If this book has inspired you to have a go at painting from photographs, why not start with the ones shown here? These are scenes I have photographed with painting in mind, that are in my view, ripe and ready to be translated into paintings.

Sandsend near Ullswater

This scene is in the Lake District in the UK. I think this is a good composition, but unfortunately I was there on an overcast day, so the light is a bit flat and uninspiring. However, it is for this reason that I have included it in this section, so that you can think about how you would like to adapt it. Here are a few questions you might want to ask yourself:

Could I make the background hills a touch higher to add a bit more drama?

Do I include the cars?

What colours can I use to give the whole scene a brighter appearance?

Should I remove some or all of the trees on the left, as they obscure the farmhouse?

Should I try to reveal a bit more of the river?

Beached Boat

This is a simple scene but, if handled correctly, it could make a good little painting. Ask yourself:

Should I alter the height of the horizon line where sea meets sky?

Some of the buildings on the little peninsular are not particularly attractive; how should I treat this?

How can I make that peninsular appear further away than the foreground?

The sand is a definite grey; am I happy with that colour?

How should I treat the bush on the right?

Hovis Café

This house near Youlgreave in the peak District was for many years a café, and was perfectly placed for a welcome pit-stop on walks through this picturesque area. It had an old advertising sign for Hovis bread in the garden, hence the name. I took this photograph on a very cold, dull winter's day while being filmed out and about sketching for a DVD. Ask yourself:

Can I make the scene more colourful and the light less flat?

What about that tree in the foreground?

How much detail should I put in the cottage and garden?

How should I treat the background?

Note that my painting from this photograph is shown on page 128.

Loughrigg Tarn, Cumbria, UK

This one is already quite a good composition, but there are a few questions worth considering.

The trees are almost silhouettes – should I put more light into them?

How can I make the distant hills look miles away?

How can I make the middle distance hills look further back than the foreground?

The sky on the photograph has very little detail in it; how can I make it more interesting in my painting?

Glossary

Colour temperature All colours have warmer or cooler variations. Warm colours tend to look nearer; cool ones recede.

Complementary colours These are opposite each other on the colour wheel such as red and green, blue and orange.

Counterchange Placing light and dark tones next to each other to create impact.

Dry brush work Creating texture by using a thick mixture of paint and dragging the flat of the brush over rough paper.

Format The shape of the painting, for instance landscape, portrait, panoramic or square.

Glazing Painting a layer of transparent colour over a part of the painting that has dried.

Gouache An opaque type of paint that can be used with watercolour, with care, when needed.

Limited palette Keeping to a limited number of colours to achieve a harmonious look to a painting.

Lost and found To create this effect, the edges of a distant hill, for intance, are shown clearly in places but faded and disappearing in others.

Plein air Painting outside on location, rather than in the studio.

Rule of thirds The compositional rule of placing items of interest one third in from any of the painting edges.

Tonal value How light or dark an area of a painting or drawing is.

Wet into wet Painting wet colour onto a wet background to create soft effects.

Index

Hovis Café

The photograph that inspired this painting is shown on page 126.

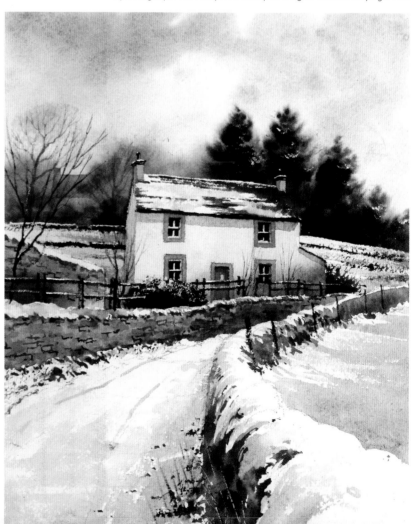